APTEKAR

Ken Aptekar

Painting Between the Lines, 1990–2000

Essays by

Dana Self
Kemper Museum of Contemporary Art

Linda Nochlin
New York University Institute of Fine Arts

H. Aram Veeser
City College of the City University of New York

Kemper Museum of Contemporary Art
Kansas City, Missouri

Ken Aptekar: Painting Between the Lines, 1990–2000 and the exhibition tour are organized by the Kemper Museum of Contemporary Art.

EXHIBITION TOUR

Kemper Museum of Contemporary Art
4420 Warwick Boulevard
Kansas City, MO 64111
September 16–December 2, 2001

The College of Wooster Art Museum
Sussel and Morgan Galleries
Ebert Art Center
1220 Beall Avenue
Wooster, OH 44691
January 14–March 8, 2002

Muscarelle Museum of Art
College of William and Mary
Jamestown Road
Williamsburg, VA 23185-8795
August 24–October 6, 2002

© 2001, Kemper Museum of Contemporary Art
All rights reserved.

All images © Ken Aptekar.

Library of Congress Control Number: 2001087866
ISBN 1-891246-05-4

Kemper Museum of Contemporary Art
4420 Warwick Boulevard
Kansas City, MO 64111

Designed by Cheryl Johnson, S&Co. Design, Kansas City, MO
Edited by Terry Blakesley, T. Blakesley, Inc., Kansas City, MO
Printed and bound by ColorMark, Merriam, KS
Distributed by University of Washington Press, P.O. Box 50096, Seattle, WA 98145-5096

Photo credits:
D. James Dee, p. 42; Theresa Diehl, pp. 74, 75; The Jewish Museum, New York, NY, p. 39;
Jeff Sturges, pp. 69, 71.

COVER:
Ken Aptekar, *I watch him in the mirror* (detail), 1995
oil paint on wood, sandblasted glass, bolts, 60 x 30 inches
Collection of J. Cassese and S. Merenstein, New York, NY

Ken Aptekar, *Years Ago I'd See Red* (detail), 1998
oil paint on wood, sandblasted glass, bolts, 60 x 30 inches
Collection of Esther S. Weissman, Shaker Heights, OH

BACK COVER:
Ken Aptekar, *Was für ein Name ist denn eigentlich Aptekar?*, 1994
oil paint on wood, sandblasted glass, bolts, 30 x 30 inches
Collection of Dr. Jeff Gelblum, Miami, FL

TABLE OF CONTENTS

v
Acknowledgments

1
Ken Aptekar: Writing Voices
by Dana Self

19–29, 39–47, 65–75
Plates

31
Uncertain Identities: Portrait of the Artist as a Young Jew
by Linda Nochlin

49
Judgment, Rescue, and the Realignment of Painting
by H. Aram Veeser

79
Works in the Exhibition

85
Biography

ACKNOWLEDGMENTS

A ten-year retrospective exhibition of the work of an artist as prolific as Ken Aptekar was a daunting task which could not have been completed without a host of convivial, hardworking, and generous comrades and supporters. Ken Aptekar was mannerly to a fault, answering my numerous questions in person, via e-mail, and by telephone for over a year. Bernice Steinbaum, his dedicated gallerist of Bernice Steinbaum Gallery, rose to every challenge. We thank the lenders who generously agreed to part with their beloved paintings for the duration of the exhibition's tour, without whom the exhibition could not have happened. They are Carol Zemel; David Lipton; Mary and John Felstiner; Dr. Gail Postal; A. Ostojić; Dr. Jeff Gelblum; Saied Azali; J. Cassese and S. Merenstein; Howard E. Rachofsky; Will Foster; Jack Shainman Gallery, New York, NY; The Jewish Museum, New York, NY; Bernice Steinbaum Gallery, Miami, FL; John Burger, M.D.; the Corcoran Gallery of Art, Washington, DC; Louise and Ernest De Salvo; Eunice Lipton; Esther S. Weissman; Dr. and Mrs. G. Bronson; Jon and Carolyn Younger; Alice and Walker Stites; Steven Robman; Aaron and Marion Borenstein; Robert and Maxine Peckar; Harold and Bernice Steinbaum; Dr. Jaime and Miriam Wancier; a private collector; and the Kemper Museum of Contemporary Art. Thanks to our colleagues Kitty Zurko, Director of The College of Wooster Art Museum, The College of Wooster, OH; and Ann Madonia, Curator of Collections, Muscarelle Museum of Art, College of William and Mary, Williamsburg, VA; for embracing the exhibition.

The Kemper Museum acknowledges the generous support of Bank of America for the 2001 Artists-in-Residence program. Financial assistance has been provided by the Bartlett and Company Grain Charitable Foundation; the Francis Families Foundation; the Arvin Gottlieb Charitable Foundation, UMB Bank, Trustee; the Hallmark Corporate Foundation; the Muriel McBrien Kauffman Foundation; the David Woods Kemper Memorial Foundation; and the Missouri Arts Council, a state agency. Midwest Express Airlines provides travel for research and the Museum's

visiting artists. Additional support is provided by *The Kansas City Star*, and vital corporate, foundation, and individual contributions.

The Kemper Museum is grateful to Shirley and Barnett Helzberg, the Earl J. and Leona K. Tranin Special Fund of the Jewish Community Foundation of Greater Kansas City, and Patricia and John W. Uhlmann for their support of this exhibition. Generous contributions were also made by Brookside Antiques and the Zoglin Family Fund. The Museum also extends special thanks to our friends Carol and Dennis Hudson and Judy and Alan Kosloff.

The staff of the Kemper Museum supported the exhibition from its inception. Special thanks to the board of trustees and our patrons, Bebe and Crosby Kemper, for thinking as much of Ken's work as I do. Special thanks to director Rachael Blackburn who, new to the Museum, was enthusiastic and supportive; Dawn Giegerich for overseeing the loans, packing, and shipping; Jason Myers for his own artist's sensitivity while installing the exhibition; Walter Dietrich, Margaret Keough, Kristy Peterson, Linda Off, and the rest of the terrific Museum staff. Cheryl Johnson of S&Co. Design created a stunning book to accompany this exhibition, and Terry Blakesley was an excellent editor.

Linda Nochlin's and Harold Veeser's contributions to the catalogue expand the scholarship on Aptekar in radiating circles of brilliance. Particular thanks to Harold, who has encouraged me and my work for years, and to Rachael Blackburn, Kitty Zurko, and Michelle Bolton King for reading drafts of my essay. Devoted gratitude goes to Jason Myers.

—Dana Self, Curator

Ken Aptekar: Writing Voices

by Dana Self, Curator

WITHOUT WORDS AS WITNESSES THE INSTANT (WILL
NOT HAVE BEEN) IS NOT. I DO NOT WRITE TO KEEP. I WRITE TO FEEL.
I WRITE TO TOUCH THE BODY OF THE INSTANT WITH THE TIPS OF
THE WORDS.

—Hélène Cixous, *Stigmata: Escaping Texts*

Ken Aptekar's paintings, borrowed from art history's
genealogy and amplified by his words and text, are anecdotal
analyst to the contested interpretations of identity, masculinity,
personal authority, Jewishness, and the slippery history of art. By
appropriating paintings from Western art history and combining
them with witty and poignant autobiography, Aptekar knits
together art history and biography's parallel dialogue. Combining
compelling and startling text with sometimes incongruous imagery
borrowed from art history's most established and often revered
figures, Aptekar sustains emotionally intimate yet broadly accessible
narratives. Mining his memories often leaves us breathless. His
confessional colloquy with painters El Greco, Manet, Boucher, and
especially Rembrandt; his family, museum-goers, and himself
provides the paintings' personal and emotional plenitude that
expands the dominion of interpretive possibilities. Notwithstanding
the visual, intellectual, and emotional impact of the "masterpieces"
he repaints, for it is easy to be swept away by the fecund beauty of
a Boucher, Aptekar suggests that autobiography is the tsunami
that carries us across time, washes the grit from between us, and
exposes that which we already suspect; we are more alike than not
and our stories, our words are our witnesses.

Over the past ten years Aptekar's text has changed from a single word or short phrases to narratives exploring the myriad guises that constitute a complex individual. He has been incorporating text on glass in his work since 1990, starting with a series of silverpoint drawings of medieval armor with small beveled glass "labels" bolted onto the surface of the drawings. For Aptekar, the armor was a pretext for mocking men's fear of vulnerability. Aptekar's beautifully intricate drawings of armor demonstrate the armor's directive against things soft, vulnerable, and feminine. (Art) history is replete with images of men's fear of and attempts to conquer the feminine. Of a recent exhibition at the Louvre, *Posséder et Détruire (Possess and Destroy)*, Michel Régis discusses Picasso's rendering of the god Paris: "The more [Paris] is armored in metallic machinery, the more lightly dressed are the goddesses. What impels Paris's lavishly complicated and bristling armor is … the panicked fear of the feminine."[1] While Aptekar unwraps and then mocks men's fears—cleverly, by insinuating they are armored and locked in—his approach is not Picasso's aggressive, self-empowering sexual differencing, but rather one of wicked irony. In *Safe*, 1990, Aptekar has drawn a beautiful but closed armor helmet. The delicate drawing and intricate metalwork play against the helmet's protective purpose, suggesting that the armor is palliative rather than curative—the protection it offers is only temporary and laughingly metaphorical. The text, "Safe," compromises the security the helmet can only imply, and delicately at that. By isolating the beautifully drawn image on the paper, Aptekar highlights the alienating effects of emotional armor, which ultimately produces the opposite effect it intends. Aptekar suggests that the armor is ludicrously gratuitous; while in his work, Picasso reinforces its essentiality against the feminine. Closeting ourselves against emotional vulnerability paradoxically leaves us more exposed than embracing its inherent risks, and we become as alienated as the single helmet Aptekar pictures. By deriding men's fears and respondent masculine measures, Aptekar perhaps calls into question events from his own childhood and the imperfect path along which boys are reared into men.

Formally, Aptekar moved from using small glass fragments to placing an entire sheet of glass over his image. *Oversensitive*, 1990, a single panel painting with the same size sandblasted-text glass covering it may be Aptekar's response to *Safe*. Developing this signature style, Aptekar metaphorically shifts from the sharp irony (irony is often central to Aptekar's commentary) of *Safe* to what may be a less savagely satirical, although ambiguous painting. Here, Aptekar reimages a portrait of a 15th-century bishop whose compassionate expression is either

augmented or scorned by the etched word "Oversensitive." Aptekar's choice—his source for *Oversensitive* is a Tyrolian polychromed 15th-century wood sculpture—capitalizes on the fact that the damaged areas of the face suggest an embattled, humbled, even teary-eyed human figure. Aptekar suggests the polarities embedded in men's emotional lives. Men are often simultaneously valued and disdained for developing their compassion and vulnerability, attesting to masculinity as a site of anxiety and instability. Through *Safe* and especially *Oversensitive*, Aptekar implies the emotional and corporeal fatigue inherent in striving to be a fully integrated human, let alone a fully integrated man.

In *Answers/Questions*, 1992, Aptekar circumscribes an underlying restlessness in many of his paintings: the personal quest for autonomy and self-determination, the restless desire to understand or dispute any relationship between the physical and spiritual and how that shifting relationship may impede our autonomy. Aptekar chose Raphael's *Vision of Ezekiel*, ca. 1518, and Rembrandt's *The Angel Stopping Abraham from Sacrificing Isaac to God*, 1635, for his source paintings. The word "Question" is sandblasted into the glass over the Rembrandt and "Answer" into the glass over the Raphael. Rembrandt and Raphael were both prominent sources for Aptekar's early works, yet Rembrandt remains ambiguous and therefore still challenging for Aptekar, as he also has for Rembrandt scholars and attributors. Of *Answers/Questions* Aptekar has written: "And so the anxiety of ceaseless Jewish questioning is contrasted with the harmonious calm of Christian certainty."[2] And while Aptekar could be taken to task for unilateral assumptions about who is spiritually unruffled and who is not, the idea of Jewish questioning, of his own questioning, vibrates through all his paintings. Jewish questioning may emerge from the Talmud, the fundamental code of Jewish law and practice. Aptekar understands that the foundation of Talmudic study is questions and answers, as the text is built upon question upon question. His own information processing, both personally and artistically, also emerges from this radiating ripple of Jewish questions. The image in Raphael's painting is one of omnipotence and surety, while Rembrandt portrays Abraham's startled visage at the moment the angel arrests the infanticide directed by God as a test of faith. Aptekar's painting choices suggest that the same faith that may comfort some also leaves others with uncertainty. The faith—or dearth of it—that we may look to for answers provides questions only. Aptekar's comments on this piece about ceaseless Jewish questioning thread the needle that stitches this ongoing examination and inquest of his work.

Linked inextricably to the notion of inquiry, questions about Rembrandt percolate within Aptekar's body of work. Rembrandt may embody the essence of Aptekar's work: questions of authenticity, authority, identity, and questions of history's generosity, or not, towards an artist. Aptekar's ongoing and intimate dialogue with Rembrandt surfaces in many of his paintings. In *Was für ein Name ist denn eigentlich Aptekar?*, 1994, Aptekar asks, "So what kind of name is that, Aptekar?," a reference to the not-so-subtle desire to sniff us out, brand us, and identify the "others" among us. (Aptekar's 1995 painting *"Goldfinch. Used to be Goldfarb."* exposes a painful cultural reality of name-changing to avoid this anti-Semitism.) The source for *Was für ein Name ist denn eigentlich Aptekar?* is a Rembrandt painting of his son Titus. Titus's beautiful red hair may refer to Aptekar's own red hair, which Aptekar discusses in a 1996 painting *Where'd you get the red hair? they ask.* The text continues from there:

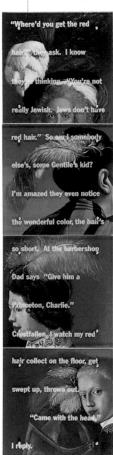

> I know they're thinking, "You're not really Jewish. Jews don't have red hair." So am I somebody else's, some Gentile's kid? I'm amazed they even notice the wonderful color, the hair's so short. At the barbershop Dad says "Give him a Princeton, Charlie." Crestfallen, I watch my red hair collect on the floor, get swept up, thrown out. "Came with the head," I reply.

This painful episode—punctuated by the anti-Semitism, the identity confusion, the inability of the child to assert control over his own body, thus the self-protective wisecrack—demonstrates how Aptekar almost never stops theorizing his emotional development and his Jewishness and how they radiate from his body into the social sphere and back again. Aptekar has situated his autobiographical private world into a nonnegotiably public space. In his ongoing private and public dialogue with Rembrandt, Aptekar questions Rembrandt's motives as artist and citizen and how his own life as artist/author overlaps. In a letter to Rembrandt Aptekar questions his relationship to Jews, specifically, why Rembrandt lived in the Jewish quarter:

> That decision has had a lot of meaning for me, and for other Jews over the years. Books have been written about you in relation to Jews. Were you more comfortable living among a marginal group because you felt in some way marginal? Or was it just because you could get a better deal on a big house? ... Did you know, Rembrandt, that you are among the most famous, most respected artists in the world? When

Where'd you get the red hair? they ask. 1996, oil paint on wood, sandblasted glass, bolts 80 x 20 inches, Collection of the Progressive Corporation Cleveland, OH

people think masterpiece painting, it is you who comes to
mind. And the thing they value most is how you portrayed peo-
ple, and yourself, in all those self-portraits, with such insight,
empathy, and wisdom.[3]

Autobiography is the covenant between Aptekar and Rembrandt,
Rembrandt's painted and Aptekar's written. In fact, Rembrandt depicted
himself more than any other artist of his time: "approximately fifty times
in paint, twenty in etching, and about ten times in surviving drawings."[4]
What did he know that other 17th-century Dutch artists did not? His
self-portraits suggest that he knew the value of his own authorship, his
own authoritative voice. Aptekar reveals parts of himself through his text,
often with a wince-inducing vulnerability, while Rembrandt reveals him-
self through his many self-portraits. Both artists raise more questions
than provide answers.

Aptekar's autobiographical imprimatur cuts an empathetic
passage through his work. Histories of vulnerability, loss, love, and
anxiety suggest that anecdote is our closest ally in creating community.
Aptekar understands that his stories stand in for ours even if the details
vary. Stories of his father are poignant reminders of familial connections
we may have, lost, desire, or never had. Tied to each other through
clothing—Aptekar's often theatrical choices fortify the narrative—Aptekar
weaves a story of himself and his father through images of apparel. In
We went to the tailor together, 1995, Aptekar describes going to the tailor
with his father for his bar mitzvah suit. The suit embodies the young
boy's desire to be a man like his father and older brothers. An excerpt of
the text reads: "I knew that who I was would change more from wearing
the suit than from turning 13. *That's when you become a Man*, they said.
I couldn't wait to grow as tall as my brothers; I longed for the day my face
would look like it did when I sucked in my cheeks." Aptekar's longing to
be like his brothers and his father is embedded in the suit, emblem of
the loved body. The suit Aptekar has had made for his coming of age
ceremony is the suit of a man, not the boy he actually still is, and
experience suggests that clothing can reconfigure us, enable us to cross
genders and appropriate others' personae by adapting their dress.
Aptekar's source paintings for *We went to the tailor together* are Bronzino's
Portrait of a Young Man, ca. 1530s, and Meléndez's *Portrait of the Artist
Holding a Life Study*, n.d. Each painting emphasizes clothing's luxury and
its ability to bestow upon the wearer grace and beauty. The power of dress
lies in its contribution "to the making of a self-conscious individual
image, an image linked to all other imaginative and idealized visualiza-

tions of the human body."[5] In the two paintings from the sixteenth and eighteenth centuries we find the central characters dressed in black, which was in itself part of a charged sartorial code. According to Anne Hollander in *Seeing through Clothes*, by the sixteenth and seventeenth centuries, black clothing had become a "rich bourgeois fashion rather than the courtly one it had originally been."[6] She continues:

> Showing the edge of the white chemise or the white collar of the shirt was an intrinsic part of the mode in much fifteenth-century costume, and it became an increasingly formalized element of sixteenth-century dress. Thus if a costume was unusual because it was black, but the collar was nevertheless white as usual, the point was sharply made that the wearer was first of all conventionally dressed; and if color was modish, he was also making a subtle antifashion commitment and involving all that black implies. ... The bourgeois or professional flavor that black had acquired ... added the idea of modesty to its basic drama: a recurrent, perverse use of black, which intends to strike a note.[7]

That note has sustained itself. Black clothing retains its polar reputation. It is still worn for mourning and black tie events, by impoverished bohemians and uptown elite, and is always an easy fallback when nothing else makes sense. Bronzino's and Meléndez's elegantly black-clad men suggest the multiple meanings behind dress, masculinity, and their construction just as Aptekar's story suggests his transformative fantasies of clothing. He understands its ability to locate himself in the past and the future simultaneously—the man remembering the boy who dreams of becoming a man—and is jettisoned into perfection.

Aptekar also invokes the remembered presence of the body in *I watch him in the mirror*, 1995. By picturing beautiful ruffled collars from Rembrandt portraits, Aptekar magnifies his compassionate text about a loved embrace.

> I watch him in the mirror.
> Carefully, he drapes
> the tie around
> my neck and folds the
> shirt collar over it.
> *See, this goes here*, he

says, *then under there,*
over and through
and back around.
He wants me to learn
the Windsor Knot.
I am encircled by his arms.

Aptekar's rhythmic prose emulates the rhythm of the knotting lesson. We hear the tender instructive voice of the father/brother/lover and feel his gentle touch on our bodies as we follow his slow and steady example. The collars, fluttering gracefully down the painting's height, encircle the life-sustaining carotid artery—heart to brain—stimulating Aptekar's and my response to the touch, "I am encircled by his arms."

As the foundation underlying all of Aptekar's paintings, autobiography's confessional vulnerability intertwines seamlessly with Aptekar's source paintings. He exercises his authority over the paintings he co-opts and the stories he uses. The performative nature of Aptekar's work—for the paintings and the texts as scrims are inherently theatrical—is enhanced by the inclusion of the strangers-as-actors he gathered from focus groups associated with his two major public projects with the Corcoran Gallery of Art, Washington, DC, and the Victoria & Albert Museum, London, England. The exhibitions also demonstrate Aptekar's ability to absorb the reactions of his viewers so completely that their autobiographies/roles seamlessly mesh with his. Yet the stories still retain the authorial presence from the individual (whom we cannot know like we know Aptekar) who uttered them. The stranger's confessional retains authoritative dominion, and everyone's history seems to resonate from Aptekar's own history. The phenomenon is simultaneously incomprehensible yet natural because the chosen viewers' stories read as emotionally exposed, a circumstance abetted by Aptekar's personality, which feels so grounded in listening that viewers seem to feel confessional with him. It is unsurprising that he elicits such candid responses from viewers when they are asked to respond to paintings. In the 1997 project at the Corcoran, *Ken Aptekar: Talking to Pictures*, Aptekar made a series of paintings based on works in the Corcoran's permanent collection. Aptekar based his text on discussion groups with elementary school children, high school students, Corcoran School of Art students, museum guards, and visitors to the museum.[8] Some of the most amplifying and forthright prose from this project come from the museum's security staff, who spend their days protecting the art, and who may find those days stretching long into tedium. Museum security officers respect and often

love the works of art that they protect. When queried about an interior scene painting by Walter Gay, *View of a Salon in the Musée Jacquemart André*, 1912, Fatoumata Parris responded:

> "I'd just look around and observe," Fatoumata Parris, a guard at the Corcoran Gallery of Art, tells me. "I wouldn't sit in any of the chairs, because they look too pretty to sit in. No, I wouldn't touch anything," she says. "I'd just observe."

Ms. Parris has collapsed her job duties—observing and protecting—with personal feelings of how she would act outside of her profession and in someone else's space, for instance, the space depicted in the painting she protects. In *Maybe he's coming to the new land*, 1997, another security officer suggests that the beautifully solemn boy in the painting is an immigrant to New York, yearning for a new life; perhaps this is why she, herself, likes the painting so much. Here Aptekar combines two different paintings, William Trost Richards's *Coast of New England*, 1894, and George Yewell's *Brooding Young Boy*, 1867. The boy may represent the seemingly borderless potential not only of youth, but of shedding one's past for a different future. Aptekar's confessional dance with his own immigrant history plays out in the paintings.

In his most recent public project for a collaboration between London's Serpentine Gallery and the Victoria & Albert Museum (January 30–April 1, 2001), Aptekar worked with six different focus groups including "recent art school graduates, learning-disabled gardeners, Afro-Caribbean elderly women, Spanish immigrants, redheads, and literacy students" to solicit comments on the works of art he had chosen from the Victoria & Albert Museum's collection.[9] He titled his project there, *Q&A, V&A*. In *I ask questions*, 2000, he superimposed text from a conversation with the caretaker of the learning-disabled gardeners about Gustave Courbet's *L'Immensité*, 1869, over the painting of the sea and a stormy sky:

> I ask questions, it's a Jewish thing. Here's an example: what detail of Gustave Courbet's seascape would you like me to cut out for you to take home? Chris answers, "A little square from the center." He explains, "A bit of sea, a bit of sky. I do like to go to the sea and stare out." What, I continue, is on the other side of the horizon? "Who knows?" Chris answers Jewish-style, a question with a question. "That's the reason I like the painting. It's empty, a place to think about nothing." I wonder, what's that like?

I ask questions
2000, oil paint on wood, sandblasted glass, bolts
30 x 30 inches, Collection of Richard Levy and Dana Asbury, Albuquerque, NM

For the artist/performer/writer/storyteller, the idea of thinking of nothing is unimaginable, antithetical, and counterintuitive to the very work on which he has had the text sandblasted, underscoring the painting's newly minted paradoxical tension. Chris's seemingly unconscious comment resonates against the painting and against the verbalizing/textualizing of "think[ing] about nothing," as if this were actually physiologically possible.

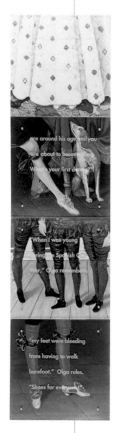

In another work from *Q&A, V&A*, Aptekar turns to the theatricality of dress and its mnemonic powers in *Olga rules*, 2000. Like Aptekar's own immigrant grandparents, Spanish immigrant Olga Sotuela recalls the struggles of her abandoned homeland when pressed into anamnesis by Aptekar. The text over four paintings of beautifully shod, privileged feet reads:

> "Edward VI was crowned at age ten. Think back," I tell Olga
> Sotuela. "You are around his age and you are about to
> become King. What's your first decree?" "When I was young
> during the Spanish Civil War," Olga remembers, "my feet were
> bleeding from having to walk barefoot." Olga rules. "Shoes
> for everyone!"

Like his democratic grandmother who married the man who ran the bicycle shop in a freer country, Olga similarly embraces equality and opportunity in the face of the iniquities of her youth. Aptekar elicits autobiographical responses from the members of his focus groups, guiding them through specific questions into confessions that intervene in the paintings' narratives, reconstructing history and ultimately us.

I'm in Madrid, 1999, is allied to Olga's story. Here, over a repainting of El Greco's *The Nobleman with His Hand on His Chest*, n.d., from Madrid's Prado Museum, Aptekar's friend Harry Fisher tells his story of fighting with the Abraham Lincoln Brigade in the same civil war for which Olga's feet bled. Despite his fear, physical pain, and dreams of desertion, Fisher stayed in the war for over a year, fighting in all the primary battles. Like most of Aptekar's subjects inscribed by text, Fisher's life experience embodies emotional and physical courage. Perhaps Fisher's heroism is more manifest than that of Aptekar's other subjects, but he is no more fearless than Aptekar's grandmother; Olga; Aptekar-the-child struggling to grow up; or the security officers at the Corcoran Gallery of Art.

Aptekar's painting choices, as we have seen in *Olga rules*, often reveal his privileging of the feminine. Not only does he often choose works that are inherently beautiful, such as those by Boucher, he gives voice to the women in his family. In *Her Father Dragged Her From Shtetl to Shtetl*, 1996, François Boucher's 1756 painting *Portrait of Madame de Pompadour* frames Aptekar's maternal grandmother's story. Like paintings about his father, Aptekar's painting about his grandmother, Mierle Pomerance, is interwoven with textiles and clothing. Aptekar begins the text: "Her father dragged her from shtetl to shtetl with a sewing machine. She fashioned clothes for Jews, sewed them on the spot. A marriage to an older man was arranged but Mierle Pomerance escaped." The story continues through her lone journey to America, her landing in Detroit, her marriage to a man who ran a bicycle shop, and her hand-sewn clothes for Aptekar's mother. It finishes with the tightly drawn reminiscence: "'A couturière your grandma could've been!' my mother says. I escaped when I became an artist." Like his grandmother, Mary, née Mierle, Aptekar escapes, circumscribing his path rather than fulfilling the one preordained for him. Aptekar further refines this idea in the painting *I'm six years old and hiding behind my hands*, 1996, also based on a Boucher painting, *Allegory of Painting*, 1765. In a lively exchange between his sister and him, with his mother—opinionated matër—overseeing, the child Aptekar demonstrates his artistry in handmade Hanukkah decorations. His text on the glass reads:

> I have a knack for it, but my mother seems worried. I see it in her eye. "Keynahora," she says in Yiddish meaning the Evil Eye should only not be watching. "Such a surgeon you'll make with those hands, keynahora, and on the weekend you can be artistic."

Aptekar clarifies his grandmother's and his desire to escape the familial shroud of expectations. Mierle Pomerance's story is Aptekar's story. Their trajectories of longing turn sharply away from tradition to fulfill their own desires. Both family members transgress cultural boundaries: the young, powerless Jewish girl refuses an arranged marriage to an old man and a young boy of middle-class privilege refuses to become a doctor, a lawyer, or whatever profession his mother and father have chosen for him, in their own post-World War II exodus and ascendancy from their immigrant roots. Aptekar's texts are proxy snapshots of family life, as surely as if they were grainy black-and-white photographs. The disruption of the narrative, through the panels of glass and the distraction of the painting underneath, punctuates the historical disruption that Aptekar privileges in his text and through the images. The exquisite

dresses in the Boucher paintings are inextricably related to the garments that Mierle produced (and could have, as a profession, according to Aptekar's mother) and the fulfilled desire of the boy and the man to become a painter. In Boucher's *Allegory of Painting*, the painter paints, her canvas held aloft by putti who stare unabashedly at the subject of their adoration, as does Aptekar, who paints the garments, à la Boucher, that his grandmother could have made, had she wanted to. She enjoyed her emancipation with a young man and a bicycle shop. Aptekar gained his in becoming an artist.

 What is the effect of reproducing "masterpiece" paintings? How does Aptekar's interpretation of these paintings shift their meanings over history's distance? Of course, by reimaging them, Aptekar has already blurred the paintings' original readings because they have been shape shifted out of their time into our own. They are changelings. Our viewing is informed by who we are and what we may or may not know (or care) about the paintings' origins. Aptekar's text, then, as a scrim over the works, both distances us from history's narratives and draws us nearer intellectually, emotionally, and physically by our desire to look through the glass to the paintings' surfaces which are alluringly sheltered. Yet, Aptekar notes his desire to "demolish the illusion of a unified whole, the 'window' into reality that historically has been a goal of painting."[10] Aptekar's fragmenting of the paintings he chooses—the separate panels repress the paintings' narratives—effects a stuttering of the image. By disrupting a painting's visual field, the painting loses narrative continuity because it is only a fragment and does not, in fact, stand in for the dematerialized whole. What kind of social energy do these fragmented images from the palaces of Western art engender? And how does Aptekar's text undermine or underline those images and their places in art history's lineage? As Aptekar notes of the segmenting of the paintings, this new context for them cleaves them from art history's servitude, challenging the image's cultural authority. The Rembrandts, Bouchers, and others are reinvested with new purpose. A fragment of a 17th-century Dutch still-life painting by Pieter Claesz suddenly becomes the platform for parents whose mealtime struggles to get their children to eat became dramatic world politics. In *"People all over are starving,"* 1998, Aptekar remembers with vivid clarity his parents' entreaties:

> "People all over are starving," my parents report.
> Africa, China, God knows where. If I leave one
> forkful of brisket on my plate, a solitary green bean,
> some naked child in the Congo will drop dead.

The still-life painting of plenty, fragmented against a beautiful background and designed to embrace life's riches, is inverted to a parental reprimand, a reminder of all we have in the face of the entire world's needs. By recharting their passage over time and knocking the paintings off their center with his stories and ours, Aptekar pockets a new site of resistance and intervention for these paintings.

Questions of authority and authenticity are bound up in Aptekar's reproductions. The effect is multiplied when Aptekar binds himself to Rembrandt. In *CIRCLE OF REMBRANDT*, 1992, Aptekar repaints five authenticated self-portraits executed by Rembrandt between ca. 1628 and 1669, exposing Rembrandt from youth to old age. Identity as a touchstone in the corpus of Aptekar's work is emphasized when folded together with the contested authenticating work by the Rembrandt Research Project enshrouding Rembrandt's body of work. The phrase "Circle of Rembrandt" is nomenclature for works presumed to be by a follower of Rembrandt rather than by Rembrandt himself. Aptekar notes:

> This painting suggests that we might as well, at this point, include even the works *we know to be by Rembrandt* within the circle of Rembrandt. All five of the self-portraits included here are certainly by Rembrandt. But since he's become a phenomenon much larger than himself, why not just put him in the circle as well as the others?[11]

In a brilliant strategic move, Aptekar dematerializes authenticity's authority. Issues of money, power, and prestige that accompany the demarcation of masterpiece and "circle of" slip away. Do I not still love The Frick Collection's Rembrandt painting, *The Polish Rider*, ca.1655, despite the fact that it has been unauthenticated by the Rembrandt project? I do, and apparently The Frick Collection trustees do too, as it is on display in the museum. By thrusting Rembrandt into the fray of his own enormous mythology and telling us that the questions about Rembrandt are part of why we may love his works, be they "circle of" or "his," Aptekar frees us to enjoy the work on its own pictorial excellence, despite what we may know about it. Additionally, the idea of a self-portrait executed by "circle of" is absurd, obliterating self-portrait's authorship entirely. Freeing his viewers to validate their own narrative, emotional responses to paintings underscores all the painting-between-the-lines in which Aptekar has engaged for the past ten years. Aptekar's stories are ours, and the paintings he brings us back to, or newly to, are enriched by their expanded interpretive possibilities.

Our exhibition ends where it metaphorically begins, with Rembrandt and more questions. A prelude piece to Aptekar's latest series on angels is the achingly beautiful *Turn it over*, 2000, whose source painting is *Bleaching Fields at Bloemendael near Haarlem*, ca. 1670, attributed to Dutch painter Jacob van Ruisdael. The text reads:

> Turn it over and turn it over again, for everything is in it, the
> Rabbi wrote. Angels even? wondered the Jewish artist who
> studies old paintings.

According to Aptekar, the rabbi's commentary touches the ethos of Talmudic study, that is, to constantly search for new meaning and therefore ask new questions, by adjusting perspective on that which you examine. Thus Aptekar turns the beautiful and fecund landscape— a stand-in for the whole world of possibilities—over and over, seeking answers to the questions he cannot stop asking. Examination, questioning, these the heart of Aptekar's body of work, lead us into the *Angels* series.

Aptekar appropriately opens the series with a nonpainting: he has temporarily abandoned the corporeality of painting for text-inscribed glass only. The text for "*Angels?*", 2000, reads:

> "Angels? Who's ever seen one!"
> —*Gustave Courbet (1819–1877), French realist painter*

It is the perfect sentence written by the artist who was devoted to a "militantly radical Realism," and a concrete sense of realities of the political, economic, and social world he lived in.[12] "Realism," Courbet declared flatly, "is democracy in art."[13] His dismissive statement about angels—how can you even think of something you cannot see with your own eyes?—sets Aptekar's *Angels* series into motion, gathering up questions and answers he has been puzzling over for the past ten years. And so the skeptical artist tenders a series about the most ethereal— unbelievable—beings in history, angels. They are the perfect foil for the analytic, doubting, yet devout artist who paints and writes beauty as his stock in trade. In *And what if you have a message*, 2000, Aptekar's source painting is one of Rembrandt's biblical paintings, *The Angel Leaving Tobias and His Family*, 1637. Aptekar's text reads:

> And what if you have a message to send back with the angel.
> "A terrible tragedy is in the making! Can't you do something?"
> What use is a divine messenger who will not deliver?

The angel leaves us stranded as we watch, perhaps in dumbstruck awe as the fleeing angel's dress theatrically activates the space of the painting. Helpless, yet stimulated by our own questions, we, like Aptekar, seek answers from these divine beings who will not "deliver" in the concrete, earthbound manner we need, being sentient humans. Both the nonfaithful and the faithful (for we must somehow believe that the angel could deliver or we wouldn't ask the question, would we?) are tested and we struggle with our doubts and our disbelief. As always, we have questions and, like Aptekar, wonder if there are answers or only more questions.

For the past ten years, Ken Aptekar has questioned himself, family, masculinity, Jewishness, art history, Rembrandt, and Rembrandt's place in art history's constantly reevaluated and renegotiated narrative. Aptekar has excavated his private and sometimes painful history and similarly drawn out the stories that others have to tell, introducing the personal and anecdotal as public and heroic. As author, he questions and replaces history's authoritative voice with his own and with our voices and narratives, be they those of his grandmother, Harry Fisher, a museum security officer, a gardener, or a student. As a painter who is also a skilled writer, Aptekar recognizes how language can stimulate memories and evoke empathy. Like Hélène Cixous, he writes to touch the moment, to insist on the presence of that which disappears. Scratching at childhood memories, Aptekar recovers wounds and traumatic events—his own and others'—to resist and redress them. The search for discovered meaning of one's own history radiates into our own, and his family's chronicles of exile mingle with ours. Aptekar compresses the distances between himself and his audience, between us and the history of the paintings he paints, between his family's complexities and ours. By floating text in the fissures between painting and the world outside of painting, Aptekar arrests our narrative's disappearance. The essential qualities of his and our stories, and therefore, of our bodies, elongates us metaphorically and corporeally as our stories entwine with the histories of the paintings Aptekar repaints. He has ensured our continuance within and outside of his text. Like Rembrandt's evolving three-hundred-year history, our narratives will caravan themselves across history's shifting borders. Aptekar's paintings between the lines, which draw from theoretical analysis, art's shifting history, personal anecdote, and public discourse, traverse distances and synthesize the past, present, and future into a filament of interconnected and extraordinary kinship.

Notes

1. Michel Régis, "Posséder et Détruire: Stratégies sexuelles dans l'art d'Occident," Exhibition catalogue, 2000, Réunion des Musées Nationaux, Paris, p. 22, quoted in Linda Nochlin and Abigail Solomon-Godeau, "Sins of the Fathers," in *Art in America*, December 2000, p. 95.

2. Ken Aptekar written artist's statement, n.d.

3. Ken Aptekar, "Dear Rembrandt," *Art Journal*, Fall 1995, pp.12–13.

4. Svetlana Alpers, *Rembrandt's Enterprise: The Studio and the Market* (Chicago, IL: University of Chicago Press, 1988), p. 120.

5. Anne Hollander, *Seeing Through Clothes* (Berkeley, CA: University of California Press, 1993), p. xiv.

6. Hollander, p. 370.

7. Hollander, pp. 369–371.

8. Terrie Sultan, introduction to exhibition catalogue, 1997, *Ken Aptekar: Talking to Pictures*, Corcoran Gallery of Art, Washington, DC, p. 4.

9. Aptekar e-mail to Dana Self, February 2001.

10. Aptekar e-mail to Dana Self, 13 November 2000.

11. Aptekar, written artist's statement, n.d.

12. Linda Nochlin, *The Politics of Vision: Essays on Nineteenth-Century Art and Society* (New York, NY: Harper & Row, Publishers, Inc., 1989), p. 3.

13. Nochlin, p. 3.

PLATES

Plates

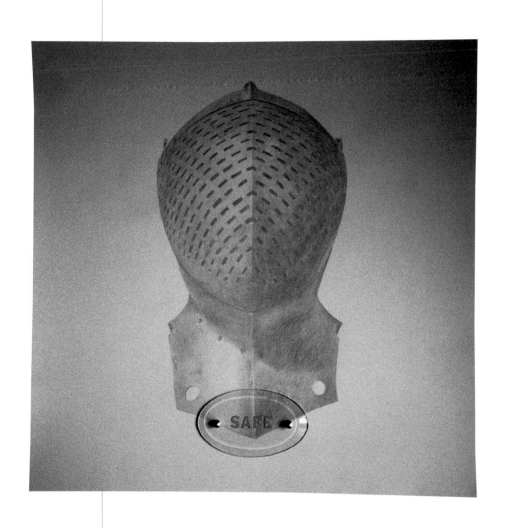

Safe, 1990
silverpoint on paper, glass, bolts
20 x 20 inches
Collection of Carol Zemel
Toronto, Ontario, Canada

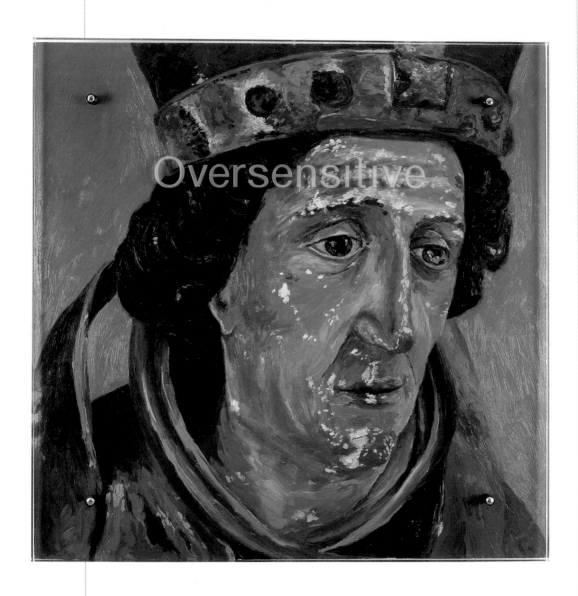

Oversensitive, 1990
oil paint on wood, sandblasted glass, bolts
30 x 30 inches
Collection of David Lipton
Toronto, Ontario, Canada

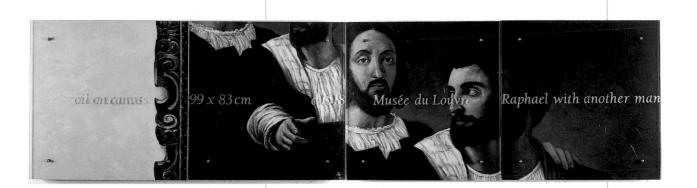

Raphael with another man, 1991
oil paint on wood, sandblasted glass, bolts
30 x 120 inches
Collection of Mary and John Felstiner
Stanford, CA

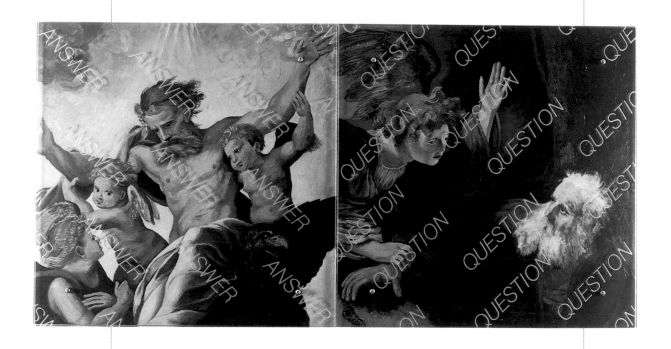

Answers/Questions, 1992
oil paint on wood, sandblasted glass, bolts
30 x 60 inches
Collection of Dr. Gail Postal
New York, NY

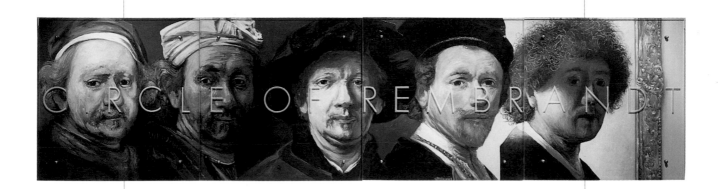

CIRCLE OF REMBRANDT, 1992
oil paint on wood, sandblasted glass, bolts
30 x 120 inches
Collection of A. Ostojić
Forest Hills, NY

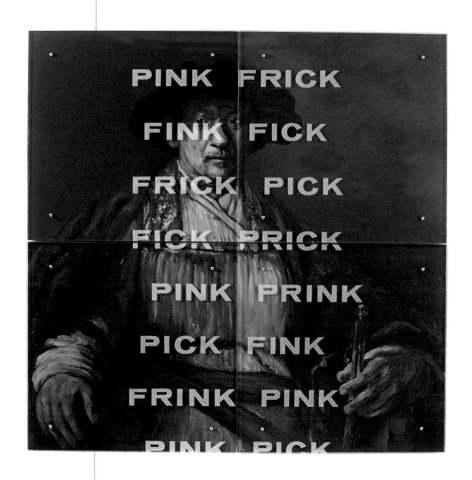

PINK FRICK, 1993
oil paint on wood, sandblasted glass, bolts
60 x 60 inches
Private collection

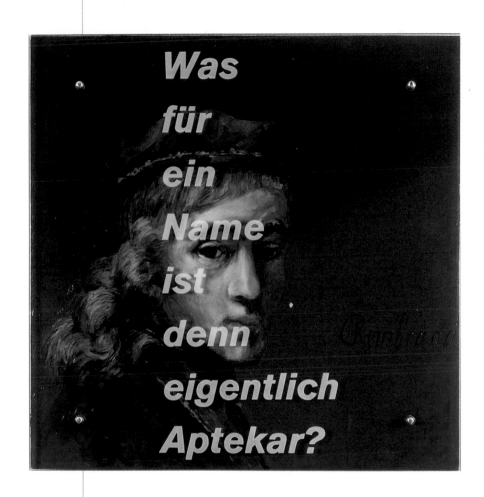

Was für ein Name ist denn eigentlich Aptekar?, 1994
oil paint on wood, sandblasted glass, bolts
30 x 30 inches
Collection of Dr. Jeff Gelblum
Miami, FL

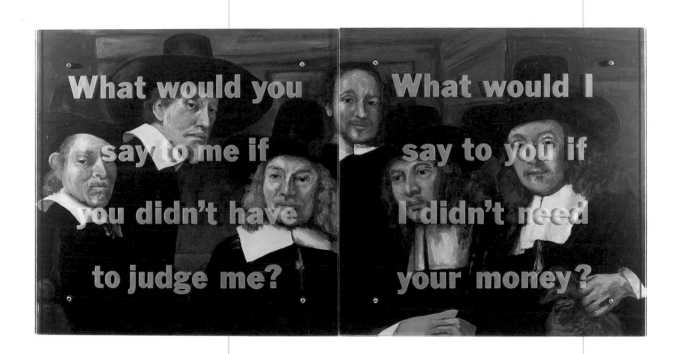

What would you say to me?, 1994
oil paint on wood, sandblasted glass, bolts
30 x 60 inches
Collection of Saied Azali
Washington, DC

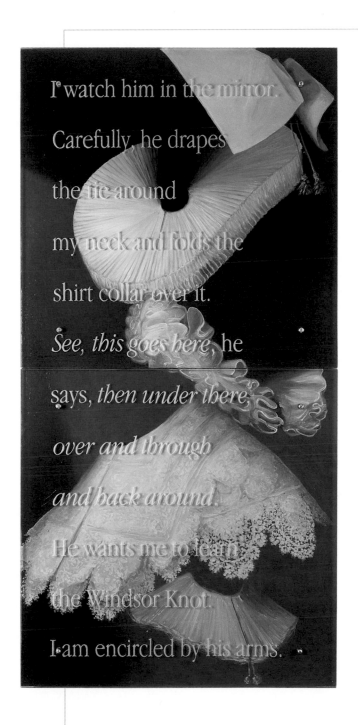

I watch him in the mirror.

Carefully, he drapes

the tie around

my neck and folds the

shirt collar over it.

See, this goes here, he

says, *then under there*,

over and through

and back around.

He wants me to learn

the Windsor Knot.

I am encircled by his arms.

I watch him in the mirror, 1995
oil paint on wood, sandblasted glass, bolts
60 x 30 inches
Collection of J. Cassese and S. Merenstein
New York, NY

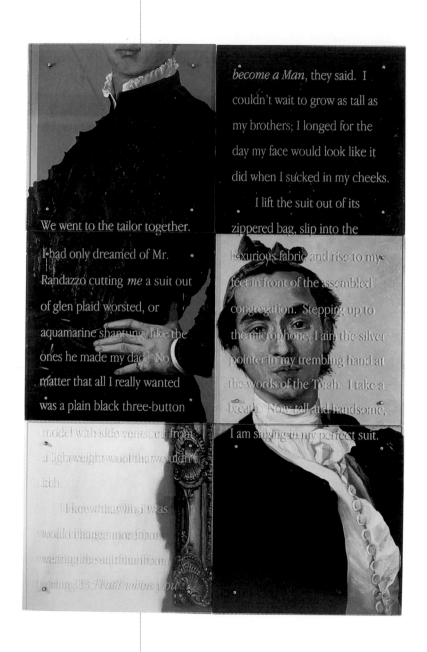

become a Man, they said. I
couldn't wait to grow as tall as
my brothers; I longed for the
day my face would look like it
did when I sucked in my cheeks.

We went to the tailor together.
I had only dreamed of Mr.
Randazzo cutting *me* a suit out
of glen plaid worsted, or
aquamarine shantung like the
ones he made my dad. No
matter that all I really wanted
was a plain black three-button

I lift the suit out of its
zippered bag, slip into the
luxurious fabric and rise to my
feet in front of the assembled
congregation. Stepping up to
the microphone, I aim the silver
pointer in my trembling hand at
the words of the Torah. I take a
breath. Now tall and handsome,
I am singing in my perfect suit.

model with side vents, cut from
a lightweight wool that wouldn't
itch.

I knew that what I was
would't change more from
wearing this suit than from
painting it. That's when you

We went to the tailor together, 1995
oil paint on wood, sandblasted glass, bolts
90 x 60 inches
Collection of Howard E. Rachofsky
Dallas, TX

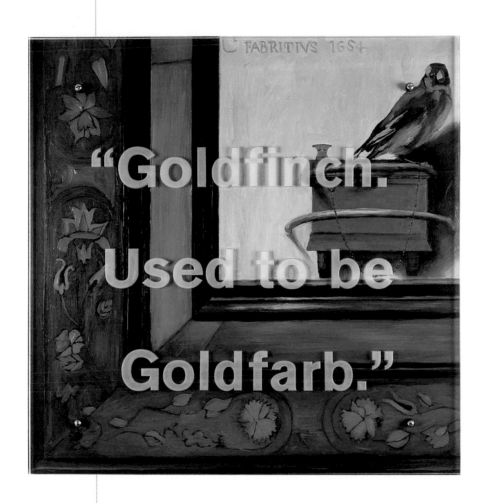

"Goldfinch. Used to be Goldfarb.", 1995
oil paint on wood, sandblasted glass, bolts
30 x 30 inches
Courtesy of Will Foster and Jack Shainman Gallery
New York, NY

UNCERTAIN IDENTITIES
PORTRAIT OF THE ARTIST
AS A YOUNG JEW

Uncertain Identities: Portrait of the Artist as a Young Jew

by Linda Nochlin

Image, words, audience. This is the triangulation of Ken Aptekar's unique contribution to contemporary art. And yet there is one other element—perhaps the most important one of all—missing from this assessment, and that is Self. Identity is always the subtext of Aptekar's work, lurking beneath the gorgeous plumage of texture and surface that makes these images a feast for the eyes as well as a text for the mind and heart. Who is this artist? What is his relation to the works he so inventively recycles? How do Rembrandt and Bronzino, Goya or Raphael work for him in this quest for a specifically Jewish genealogy? How do the Old Masters engage his identity, construct the being of Ken Aptekar, fifty-year-old redheaded Jew from Detroit? And what is the role of the beholder, ignorant or learned, puzzled or insightful, who responds, and in responding, gives birth to the multiple meanings of the work?

To answer these questions we have to begin with the visual objects themselves. Or rather, we must explore the single work, for in each the elements work differently together.

Was für ein Name ist denn eigentlich Aptekar?, 1994, poses the question in German, "So what kind of name is that, Aptekar?" over the seductive and mysterious recapitulation of Rembrandt's adolescent son, Titus. The boy glances over his shoulder, his pensive face framed by a cascade of golden hair to the left, his father's authoritative signature to the right. Can we think of Titus as a redhead and thus in some way, an alter ego of the artist himself? Being a redhead, a Jewish redhead, was important to Aptekar, as it was to me. In a way, it set him apart, objectified him like a woman. Later he found out, as I did, that red hair in the past

in Europe had been particularly associated with the Jews, with their otherness, devilishness, and ugliness. Gauguin, for instance, gives his Dutch Jewish friend, Meyer de Haan, red hair, rudimentary horns, and a satanic claw in his memorable portrait of 1889. But for us, Ken and me, growing up as redheaded Jewish children in America, it meant we were often considered non-Jewish: Irish, Scottish maybe. Red hair in Jewish American culture at once conferred the status of unique identity—my uncle used to call me "the red menace"—but confused one set of signs of difference with another.

The German language of the overlaid text, however, makes identity moot. A sinister threat shadows the beauty of the boyish face, the elegance of the facture. What kind of name is Aptekar, indeed? It is a Jewish name, and since it is asked in German, the seemingly innocent question raises, right next to youthful beauty, in fact inseparable from it, the specter of the Camps, the obscene piles of naked bodies, the fatal discovery of one's own otherness, secret dread of every Jew, no matter how emancipated. What's in a name? In Aptekar, in a Jewish name—everything: life and death, the death of an entire people, the mundane possibility of getting a job, the life of an image, the reinscription of the Great Tradition in the dilemmas of contemporary representation.

We went to the tailor together, 1995, is even more focused on the ambiguity of Jewish identity. Here, two ultimate dandies, *beaux sabros* in Ladino, the language of the Sephardim: one, Bronzino's seductively arrogant *Portrait of a Young Man*, ca. 1530s, in the Metropolitan Museum of Art, from the mouth down; the other the Spanish Meléndez's *Portrait of the Artist Holding a Life Study*, n.d., looking out at us—both in black, both sensually alluring, macho, as only black-clad young male bodies can be. That is what this picture is about, that and the primal Jewish turning point, the supreme moment of attaining group identity—the bar mitzvah. Inscribed on these models of elegant and self-confident maleness are words shaking the very foundations of traditional Jewish iconoclasm: statements about appearance being more important than being, looking good as superior to being good. On the glass covering the image Aptekar has incised: "I knew that who I was would change more from wearing the suit than from turning 13. *That's when you become a Man*, they said." Later, "tall and handsome," he is singing in his perfect suit, reading his portion of the Torah. This is, of course, how it was to be Jewish in Detroit, how to become officially a man in one's traditional culture. But more than that, it is a celebration of the glory of appearances, the birth of

the artist and his unique if ambiguous destiny. But that's the point, isn't it? Identities are never simple. The words on the glass overlay, the borrowed images, our memories and desires, are always part of identity formation; and who we are shifts, sifts, dances with the movement of the gaze on glass, the sideswipe of the glance. It is this shifty recognition, so contemporary in its inflection yet so dependent on a visual past, that Aptekar's work enables in each viewer who confronts its mixed signals.

Got a call from Nick, 1999, seems on first encounter more literally focused on the Jewish question itself. The very words incised on the glass overlaying the painting seem to pose, rather brutally, the question of Jewish identity in relation to a putative conference on Jewish culture. Ken Aptekar asks the questions I, or anyone, would ask in such a situation: "I'm thinking about what that means. Pictures of Jews? … Pictures with Jewish in the title? Pictures about wandering the land? … Paintings with questions?" It is the pictorial surface on which these questions are posed that refracts the difficulty. Jacob van Ruisdael's *Jewish Cemetery*, ca. 1655–60, faded to a haunting, ghostly, ephemeral bluish-violet, is the mysterious foil for these rational and up-to-date questions. Even more perplexingly, the image is doubled, its organic verisimilitude and geometric precision, dead branches, brooding ruins, sarcophagi, and clouds strangely doubled or reflected, so what seemed at first a simple landscape becomes something more mysterious, dark and ungraspable, like the notion of "Jewish" culture itself. This is a graveyard we are looking at, after all. Aside from its status as a famous picture from a great tradition, it trails an aura of inbuilt melancholy. Whatever vague thoughts of the brevity of human life it may have implied when it was painted in the seventeenth century, the contemporary viewer cannot look at Jewish graves without a more specific referent—or a more painful one. Jewish culture takes on a darker dye, like the muted colors of the painting, in the shadow of the Holocaust.

Yet some of Ken Aptekar's images are more down-to-earth and frankly autobiographical, more explicitly enmeshed in family history. In *I hate the name Kenneth*, 1996, Aptekar juxtaposes a four-part frieze of European Jewish faces, painted by one of the rare Jewish artists of the *fin de siècle*, Isidor Kaufmann, with a narrative of family names and their changes: Abraham to Al in one case, Chaim to Kenneth in his own. Of course, Chaim existed only as a ghost name, the memory of an unknown dead relative hovering in the background for the American-born Ken Aptekar. (My ghost name is Leah, ancestral antecedent for the classier

Linda.) Beneath the story of assimilation, alteration, and regret, loom the picturesque faces of a lost Jewish past: *Portrait of a Rabbi*, 1900; *Portrait of a Sephardic Jew*, n.d.; *The Son of the Miracle-Working Rabbi of Belz*, ca. 1897. These, one might say, are the "real" Jews, the ones that kept their names and their identities. For Americans, the choices were more complicated.

Still in a genealogical vein, but more intricately so, is the story of his grandmother the seamstress, incised on the rococo splendor of Boucher's *Portrait of Madame de Pompadour*, 1756, in Munich. Even the text incised on the glass here is much denser and more active than usual, as if in response to the decorativeness of the image, and the fall of words is tilted like the sitter. Painted on four separate panels which emphasize its artifice as an art object as well as its grand scale, *Her Father Dragged Her From Shtetl to Shtetl*, 1996, reveals its ironic unity slowly, as we realize that the genealogical narrative in question has to do with a grandmother who sewed clothes for a living. Her skill at her trade is at once supported and traduced by the aristocratic complexity and refinement of La Pompadour's costume and décor. What has Mierle Pomerance from the Old Country got to do with this epitome of 18th-century elegance? Could she have dreamt of stitching up something like the French woman's rose-embroidered, ruffle-bedizened gown? Never! And yet, Aptekar's mother declares: "A couturière your grandma could've been!" If circumstances had been different, who knows? This is the genealogy of an artist—a grandmother who could have been one, but wasn't. He is the one who got away, who escaped into the world of art and its multiple predicaments and satisfactions. Being a Jew, remembering Jewishness is part of being an artist for Aptekar, in the same way that the history of Western art is part of that project.

In previous exhibitions, Aptekar has asked his audience to give their responses to his work and the work of older artists, using their interpretations as part of the project, so that one might say that an exhibition like the recent *Ken Aptekar: Talking to Pictures* at the Corcoran Gallery of Art, 1997–98, was as much a conceptual experience as a pictorial one. This is an interesting maneuver, in that it at once neutralizes the artist and yet makes him an active player in the game of meaning. In the past, he asked questions of others, but it seems to me that the questions he asks himself are the most interesting and poignant. Ken Aptekar's openly exposed complex visual layering—oil paint on wood, sandblasted glass with writing, bolts—denies the possibility of any simplistic,

unilinear process of interpretation, any key that will unlock a final meaning, tell it like it is. "For me," says the artist, "the texts and the images are equal partners in the work."[1] Although he hastens to add that there is often a pitched battle between them. "If the image becomes merely an illustration of the text, what's the point?" he adds.[2] His paintings are now all designed on a computer, which he uses to scan source images or digital photographs. Then he arranges and rearranges, using Photoshop software until he develops an image that will work as a painting. He uses another program to write the text, select the typeface and where it will go in the image, and then produces a printout. "That's my sketch for the painting," he says, laughing.[3] The scanned image is then projected on gessoed panels and painted in regular old-fashioned oil paint. In a way, one might say that Ken can have his cake and eat it too: the sensuous pleasure of manipulating the pigment to create the image and the conceptual satisfaction of creating ambiguous post-modern meanings. Even the reflective glass panels function in this creation. Usually considered a nuisance, the reflections in the glass automatically insert the viewer's presence into the experience of the picture.

Ken Aptekar's glass-covered, written-over, repainted images exude, above all, an odor of personal memory in this exhibition, the past unrecaptured, as it always must be in the unforgiving present. The dialogue, in the case of the "Jewish" works in *Ken Aptekar: Painting Between the Lines, 1990–2000*, may be less with his viewers, more with a part of himself.

NOTES

Notes

1. Ken Aptekar, interview by author, New York, NY, 4 May 1999.

2. Aptekar, interview.

3. Aptekar, interview.

PLATES

Plates

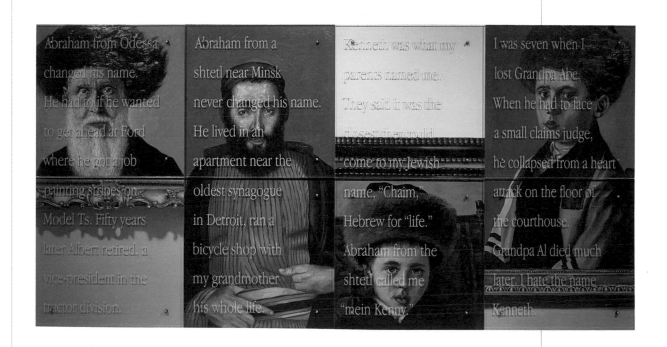

The artwork contains the following text across its panels:

Abraham from Odessa changed his name. He had to if he wanted to get ahead at Ford where he got a job painting stripes on Model Ts. Fifty years later Albert retired, a vice-president in the tractor division.

Abraham from a shtetl near Minsk never changed his name. He lived in an apartment near the oldest synagogue in Detroit, ran a bicycle shop with my grandmother his whole life.

Kenneth was what my parents named me. They said it was the closest they could come to my Jewish name. "Chaim," Hebrew for "life." Abraham from the shtetl called me "mein Kenny."

I was seven when I lost Grandpa Abe. When he had to face a small claims judge, he collapsed from a heart attack on the floor of the courthouse. Grandpa Al died much later. I hate the name Kenneth.

I hate the name Kenneth, 1996
oil paint on wood, sandblasted glass, bolts
60 x 120 inches
Collection of The Jewish Museum, New York, NY
Museum purchase with funds provided by
Barbara S. Horowitz, Howard E. Rachofsky, Ruth M. and
Stephen Durschlag, Marcia May, J. W. Heller Foundation,
Michael L. Rosenberg, the Fine Arts Acquisitions Committee,
Helga and Samuel Feldman, Caroline B. Michahelles
and Robert G. Pollock, 1997.26.1–8

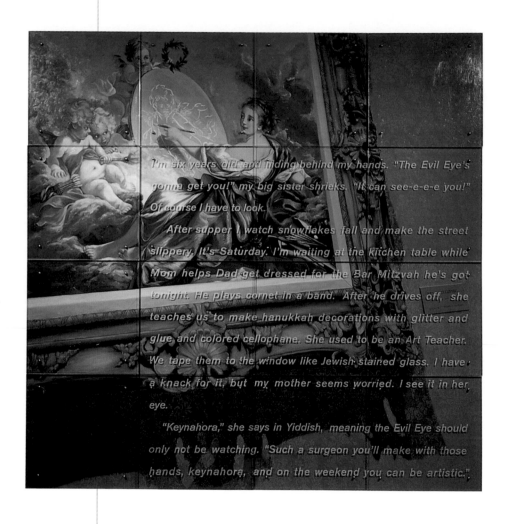

I'm six years old and hiding behind my hands. "The Evil Eye's gonna get you!" my big sister shrieks. "It can see-e-e-e you!" Of course I have to look.

After supper I watch snowflakes fall and make the street slippery. It's Saturday. I'm waiting at the kitchen table while Mom helps Dad get dressed for the Bar Mitzvah he's got tonight. He plays cornet in a band. After he drives off, she teaches us to make hanukkah decorations with glitter and glue and colored cellophane. She used to be an Art Teacher. We tape them to the window like Jewish stained glass. I have a knack for it, but my mother seems worried. I see it in her eye.

"Keynahora," she says in Yiddish, meaning the Evil Eye should only not be watching. "Such a surgeon you'll make with those hands, keynahora, and on the weekend you can be artistic."

I'm six years old and hiding behind my hands, 1996
oil paint on wood, sandblasted glass, bolts
120 x 120 inches
Courtesy of Bernice Steinbaum Gallery
Miami, FL

Her father dragged her from shtetl to shtetl with a sewing machine. She fashioned clothes for Jews, sewed them on the spot. A marriage to an older man was arranged but Mierle Pomerance escaped. Uncle Shmulik secretly arranged passage, and alone she sailed to America.

Stepping off the train in Detroit, she found a job after two days. Two weeks later Mierle, now Mary, had a boyfriend; and when the relatives she stayed with disapproved, she got herself a room. They wed in her landlord's apartment and feasted on corned beef sandwiches. She managed the bicycle shop they ran; he shmoozed with customers. Still she made my mother's clothes: a red and white gingham outfit, a pink suit with a blue organdy blouse. "A couturière your grandma could've been!" my mother says.

I escaped when I became an artist.

Her Father Dragged Her From Shtetl to Shtetl, 1996
oil paint on wood, sandblasted glass, bolts
60 x 60 inches
Collection of John Burger, M.D.
Edison, NJ

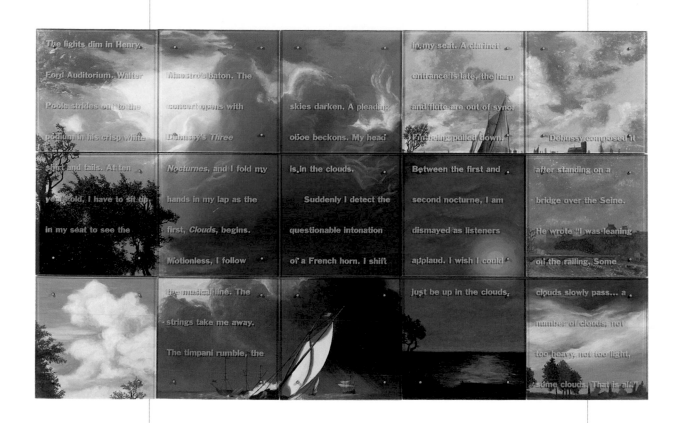

The lights dim in Henry Ford Auditorium, 1997
oil paint on wood, sandblasted glass, bolts
72 x 120 inches
Collection of the Corcoran Gallery of Art
Washington, DC
Museum purchase, 1998.18.a–o

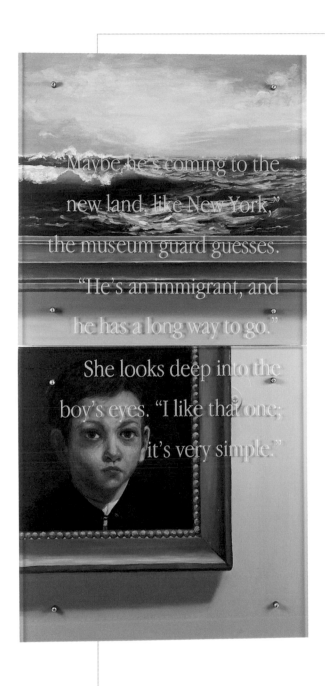

"Maybe he's coming to the new land, like New York," the museum guard guesses. "He's an immigrant, and he has a long way to go." She looks deep into the boy's eyes. "I like that one; it's very simple."

Maybe he's coming to the new land, 1997
oil paint on wood, sandblasted glass, bolts
60 x 30 inches
Collection of Louise and Ernest De Salvo
Teaneck, NJ

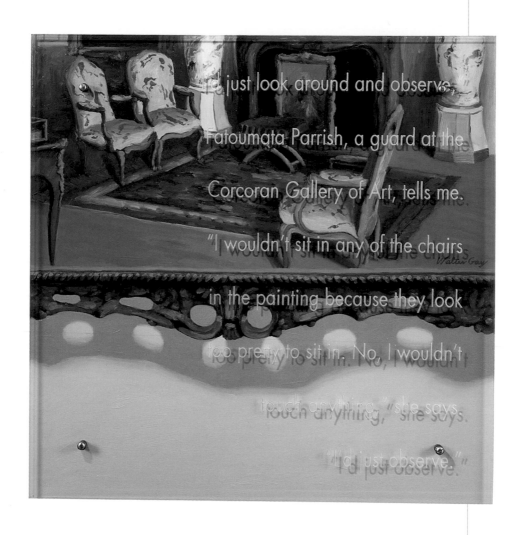

The painting text reads:

I'd just look around and observe,
Fatoumata Parrish, a guard at the
Corcoran Gallery of Art, tells me.
"I wouldn't sit in any of the chairs
in the painting because they look
too pretty to sit in. No, I wouldn't
touch anything," she says.
"I'd just observe."

I'd just look around, 1997
oil paint on wood, sandblasted glass, bolts
30 x 30 inches
Collection of Eunice Lipton
New York, NY

"Years ago I'd see red
at the drop of a hat.
After I became a
full-time artist, I
stopped exploding
like I used to at the
sight of a cabby
tossing out crumpled
McDonald's trash

while stopped for a
light. Back then, I'd
scoop the litter up and
shove the goddamn
wrapper back in the open
window of the yellow cab.
Nowadays I'm making
pastoral landscapes,
and I see less red.

Years Ago I'd See Red, 1998
oil paint on wood, sandblasted glass, bolts
60 x 30 inches
Collection of Esther S. Weissman
Shaker Heights, OH

"People all over are starving," my parents report. Africa, China, God knows where. If I leave one forkful of brisket on my plate, a solitary green bean, some naked child in the Congo will drop dead.

"People all over are starving," 1998
oil paint on wood, sandblasted glass, bolts
24 x 48 inches
Collection of Robert and Maxine Peckar
Alpine, NJ

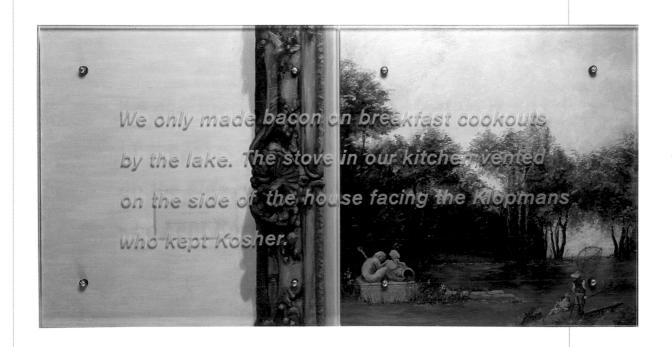

We only made bacon on breakfast cookouts, 1998
oil paint on wood, sandblasted glass, bolts
24 x 48 inches
Collection of Dr. and Mrs. G. Bronson
Courtesy Bernice Steinbaum Gallery
Miami, FL

JUDGMENT, RESCUE, AND THE REALIGNMENT OF PAINTING

Judgment, Rescue, and the Realignment of Painting

by H. Aram Veeser

On June 28, 1990, Ken Aptekar stood before his painting. He had just returned to the studio from helping a friend put a lock on a door, a skill acquired during his locksmithing years. Taxis drove by on 30th Street below, spraying puddle water. In his hands was a sheet of glass. On it he had sandblasted a brief narrative. The question now was, How to affix the glass plate to the painted surface? He considered various possibilities. He could just frame the painting and put the glass in front of the image. Or he could drill four holes through the glass, which would necessitate bolting directly through the surface of the painting. He chose the utilitarian bolts, a choice he now describes as aggressive. A nod to the part of himself that has no respect for the Art World enterprise.

Ken Aptekar: Painting Between the Lines, 1990–2000, the title of this exhibition, situates Ken Aptekar accurately. His fusion sensibility and his aesthetic of piercing, his search for the gaps in time and institutions that just might afford possibilities of escape and innovation make him a trenchant commentator on our late-Foucauldian moment. Like Foucault, he has an intense concern with framing and other means of making-visible, as well as with the dubious arts that acquire a hold over individuals "not simply by confining them but by opening up and inscribing what is hidden, unknown and inaccessible."[1] Aptekar opens and inscribes what might otherwise remain closed: Old Master paintings, groups of schoolchildren and museum guards, and his own psyche. The act of opening and inscribing rescues from silence, but it also flirts with power, subjection, and subjugation.

To date it is the rather more abstruse, semiotic aspect of Aptekar's work that has inspired the most compelling discussion. Semiotics is the science of signs, and Aptekar's text-and-image work

as measured by art historians Mieke Bal, Norman Bryson, and Linda Nochlin has secured his place among the most piercing and inventive semioticians in any field. He can, on the evidence they provide, conjure with the preeminent theorists of the sign, from C. S. Peirce and Ferdinand de Saussure to Umberto Eco and Gerard Genette—all of them linguists of daunting complexity. He has also spearheaded a moment in visual art that parallels reader-response theory in literary circles: not the text, but rather the reader/viewer's response to it seizes his critical attention. From the literary and semiotic point of view, Aptekar is a theorist of the first water.

One cannot help feeling, nonetheless, that tens of pages devoted to iconicity and indexicality scarcely begin to touch the core of so elemental and social a body of work. Insults, threats, class conflict, racism, humility, desperation, voguing, loyalty, pride, and defiance form the narrative content of Aptekar's work, and most viewers will respond to that rather than the intricate play between interpretant, signifier, and signified. Justice remains to be done to the issues of judgment, rescue, and what can provisionally be called Aptekar's new historicism.

In one of the pocket-sized prose poems that garnish Aptekar's paintings, a nightingale complains of being judged by a pig. Coping with bad judgment means confronting the high judge of painting, Art History herself. The painting of an empty frame that opened Aptekar's Corcoran Gallery of Art exhibition [*Ken Aptekar: Talking to Pictures*] alluded to the "ghosts" that had been deaccessioned from the Corcoran. They stood for paintings that had been judged wanting. Aptekar brings to center stage three aspects of framing that have helped to create our sense of the world: framing creates a distinction between the container and the contained, it makes a fixed distinction between inside and outside, and it establishes a site from which the individual can observe without becoming involved. He paints, too, the long shadows that frames throw. More radically, he challenges the founding distinction between framework and its material fleshing-out, a Cartesian duality between mind and material that he fully rejects. Finally, he relies on the anecdote as an antidote to History, and these small, pregnant stories ally him to cross-disciplinary strategists of every sort, from the New Historicists to Miles Davis.

An essayist standing outside *Painting Between the Lines* must admit that Aptekar is engaged in a sort of framing. Because a framing essay stands all too much at risk of flattening a determinedly heteroge-

neous body of work, with its bolted-together glass, spoken language, and paint, I have departed from the more invidiously leveling conventions of the catalogue essay. First, I have approached Aptekar's disarmingly accessible project as a series of gestalt shifts. One must confront initially the organs of authoritative judgments, namely the institutions of religion, family, the art world, heterosexuality. One proceeds to the way he transforms criticism from oppression into a gift. One begins, then, to perceive his rescue operations, wherein the unnoticed and defeated suddenly gain eloquent voice, yet are compelled to qualify their limited victories. Art is, here, at best a site of displaced triumph and at worst is pure absence, privation, and loss. One must in any case enjoy the interlinearity, the great chorus of unexpected voices that strive willy-nilly to attain articulate speech. In what follows, Aptekar's words are emphasized and bracketed to my essay. I did it this way to remind the reader that Aptekar everywhere lets the bolts plainly show themselves; in keeping with his project of disenchanting the institutionalized world, I avoid seamless continuities and other ersatz harmonies. And following his lead, I have occasionally slipped into autobiography.

JUDGMENT

Judgment runs across the length and breadth of Aptekar's work, cajoling and hectoring, suggesting and threatening. Bal has discussed at length the omnipresence of the vocative mood, the second-person address (think of Uncle Sam: "I Want YOU"). And consider *Oversensitive*, 1990, the single word sandblasted across Aptekar's oil-paint-on-wood rendition of the polychromed wood statue of a bishop. The bishop has soulful eyes and a delicate mouth, and those are enough to provoke some imagined viewer, maybe a manly man, to conclude: "Oversensitive!"

Or consider the terrors of judgment. The artist's grandfather Abraham collapsed and died "When he had to face a small claims judge." Only the Old Masters themselves seem up to the job of repudiating the judgments of pigs. How about Rembrandt, spitting out at the now-owner of his self-portrait, "Frick. Prick." The sampling officials of the Drapers' Guild curl their lips at the artist whom they have commissioned, but the artist gets in a good one: "What would you say to me if you didn't have to judge me? What would I say to you if I didn't need your money?" And there must have been some implied judgment to make the artist write,

"Who's to say I'm not a good Jew if I don't believe in God?" Parents are always on hand with censure. "If I leave one forkful of brisket on my plate," according to them, "some naked child in the Congo will drop dead." And even way out by the lake, the nosy Klopmans in their kosher kitchen sniff disapprovingly as the Aptekars cook their once-a-year bacon. Someone in the barbershop asks, insinuatingly, "Where'd you get that red hair?" And bolted over Rembrandt's red-haired Titus, the Third-Reichish query, "Was für ein Name ist denn eigentlich Aptekar?" ("So what kind of name is that, Aptekar?") "Raphael *with* another man" (emphasis mine) gasp the words inscribed over *Raphael and Another Man*, ca. 1518, (subtext: Raphael gay!?). Even blameless Harry Fisher, the daring young volunteer who fought on the anti-fascist Spanish front, reacts angrily against judgment: "Some people might call me a coward. But what the hell do they know about war?" Judged by a pig, the nightingale weeps. As a teacher who grades papers and ranks candidates, who judges and misjudges, I feel these works speaking to me. They judge me.

> Every artist experiences judgment, has certain people's voices whispering, saying, "That's not really good. Why did you do that? So-and-so did it better." In order for artists to make a living they're dependent on the positive judgments of others, whether people will be willing to spend money to buy their work, willing to exhibit it, or interested in writing about it—those are the three main arenas. Judgment figures both in psychological terms and in real terms; in terms of making a living, it also figures in the process of making one's work. "Is this move successful?" You need a critical faculty if you're going to be a good artist, but this critical faculty exists at the expense of your enjoyment of an aesthetic experience.

The lights dim in Henry Ford Auditorium, 1997, features the artist as a young man enjoying a concert—Debussy's "The Clouds"—until, that is, the oboes come in late, and his censure spoils his pleasure.

> I just want to be enjoying this music, but already at age ten the critical faculties start swimming in and prevent my pure enjoyment of what I am listening to.

Several works in this show represent moments when the joyous will to create encounters the demand to do good work.

To the judgmentally minded [1999] for example.
I didn't want the painting to be didactic somehow, that
there would be this one-to-one relation between the
scene of a coronation of Josephine supposedly, but in
fact of Napoleon, and the moral of the story. So what I
chose to do—and it was an impulse, really—was to
focus in on moments in the story that would be charged
and would have their own life. Focusing viewers'
attention on those specific moments, I would create an
almost cinematic narrative that would coincide on a
different plane with the text as it unfolded.

The narrative unspools two identical stories. In each,
pompous critics try to rain on a parade. And in each, the figures of
merit remain undeterred. Frowning clerics, scowling pope, tune-deaf
porker judge in vain. The talented are triumphant. On a different plane,
of course.

Yet are they really? Institutions weigh heavy on these works
from the Corcoran exhibition—school, synagogue, mental ward.

I would add to the list institutions like heterosexuality,
family, the institution of gender, the institution of organ-
ized religion even more broadly than the synagogue. The
institutional voices are all ringing in my ear and to some
extent my work is a big "Shut up" to shake loose the
burden of those institutions.

These voices can deafen you.

JUDGMENT AS CURSE

The hard-edged dystopic vision of a totally administered
world is, I think, closer to the reality we inhabit. Real wages decline,
health care grows more elusive, racism and sexism flourish, alternatives
to capitalism fade. But in Aptekar's work, a utopian gap tends to open up,
often between two competing, mutually reinforcing discourses that undo
each other even as they enable each other. One of Aptekar's finest works
is entitled, *I'm six years old and hiding behind my hands*, 1996. A mother

and son make Hanukkah decorations. "I have a knack for it, but my mother seems worried." The mother's anxious words, "Such a surgeon you'll make with those hands, keynahora, and on the weekend you can be artistic," stand ineffectually over Boucher's *Allegory of Painting*, 1765. In that picture, a half-clad woman—Painting in all her glory—points with her brush to a circular canvas, commanding, it would seem, the pursuit of nothing less than Art. This is a double interpellation—two opposing speech acts thrust up against each other.

How confusing. How enabling. For the artist turns confusion to opportunity, so as to slip between the imperatives of Art History and Bourgeois Family. As he says in *Her Father Dragged Her From Shtetl to Shtetl*, 1996, "I escaped when I became an artist."

That is not steely-eyed realism. And to be fair to Aptekar, he knows that escape is not *le mot juste*. The small fulfillments of desire and talent take place within Religion and Family and Art World, not somewhere outside them.

> If I thought my work was a rant I'd be quite disturbed. Despite the constraints in the family suggested by the painting, there's also the fact that the mother is encouraging the son to make art. Although, it's a mixed message because there are certain strings attached to that encouragement; nonetheless, here it is, you know, she's teaching him how to make Hanukkah decorations out of beautiful materials and exciting him in that way.

But then in what sense has he escaped?

Aptekar's idea is that artists thrive when institutions, aiming at one goal, are used to achieve another.

> I'm a believer in a dialectic. The painting *We went to the tailor together* [1995] … it wasn't what was intended to be transmitted to the bar mitzvah boy, that he would internalize the message of the Torah, he would feel the authority of a boy becoming a man via this religious ritual. It is rather that he felt sensually elevated into adulthood by the act of wearing a beautiful suit and

creating something beautiful and singing in front of a group. That was equally valid, in my view, but it wasn't what was intended, I suppose (laughter).

The trouble with this explanation is that dialectic is a humanist and enlightenment style of thinking about history. Marx and Hegel were dialecticians. Giambattista Vico, the 18th-century expert on Roman jurisprudence, was a dialectician who believed that human actions were helpless to stop history's unfolding: "this world without doubt has issued from a mind often diverse, at times quite contrary, and always superior to the particular ends that men had proposed to themselves … ."[2] Dialectic proposes that history has its own inevitability, and that nothing is ever lost or done in vain. Dialectic renders a fundamentally upbeat view of history because, as Hayden White observed, in it history always has a happy ending—the worker's paradise, the triumph of Absolute Spirit. It is not, however, a view a Foucauldian could hold.

RE-PRESENTATION AS RESCUE: TACTICAL STRIKE BEHIND THE LINES

Painting Between the Lines is unbelievably optimistic, rich in examples of the aleatory benefit and the unintended manumission. Consider the artist's grandmother, two weeks off the boat, bivouacked with relatives who disapprove of her boyfriend.

Grandmother simply moves out: "got herself a room." Judgment avoided is judgment annulled. Only by escaping the family does she produce Ken's mother and finally Ken, who reciprocates by taking her story to the Kemper Museum. In *I'm six years old and hiding behind my hands*, Painting rescues the speaker from mother's command to become a surgeon. Ken repays Painting by repainting Old Masters. *We went to the tailor together* gives us the boy exposed to judgment—the congregation—but shielded by art, the tailor's finely made suit. Protective, intimate, the art of the tailor swathes you in its graces. And art commemorates. In *I'm in Madrid, 1999*, Harry Fisher objects to being judged ("But what the hell do they know about war?") but in this case refuses to refuse the judgment. The painting renders its own verdict, judges Harry Fisher to be a hero. History looks, on the whole, pretty damn just.

Even unjust judgment, Aptekar's bête noire, has saving graces.

> Because I'm so schooled in the terrors of judgment, I
> learned to embrace criticism and really use it to enrich
> my work. And so any available opportunity for somebody
> to tell me what they think about what I am doing,
> I seize, because it can only make my work better, it can
> only make my understanding of my work richer, it can
> only enhance what I do because everybody's input is
> sort of a gift to me. And so whenever anybody comes
> into my studio when I'm working, I automatically try to
> get them to respond to what I am doing and tell me
> what they think. I've gotten great feedback. It's just
> made my work much better.

But the exhibition is not so utopian as to suggest that anyone or everyone can escape the crushing weight of institutions and bad judgment. Aptekar escaped by painting. His brother did not. *It wasn't my brother*, 1997, and *I drove my brother …* , 1999, afford powerfully moving articulations of solidarity in the face of hostile judgment. What really drove his brother was the misguided demands of his parents, judgments that drove him to distraction and a condition of pain that is excruciating to read about. But the two paintings also suggest the ultimate futility of hopes for easy rescue. In *I drove my brother …* , Aptekar looks on as his brother jams in a ghetto jazz bar. The brother is making music but lacks institutional shelter and critical acclaim. His damage, his vulnerability, and his literal institutionalization put us back into the darker world of Foucault and even of the Frankfurt School, with its memories of a damaged life. Which is to say, back to reality.

Aptekar is, as usual, in place to rescue the almost-lost. He figures himself as the subject of Manet's *The Plum*, ca. 1877, an onlooker but by no means a container, aloof outsider, or dispassionate framer.

> It was more a psychological circuit. The freedom and
> excitement that I saw in my brother's playing was
> thrilling to me. And then when it was squelched by a
> nervous breakdown, I saw it as tragic. So I think it
> made me wary of pursuing a creative life, but at the
> same time it exposed me to it, it made it thrilling and …
> "How you going to keep them down on the farm?" What

freedom he had now, what total freedom, but what was going to be, what was going to happen? And there's all that uncertainty in the Manet, you don't know what she is thinking about, but you really sense her intense involvement in her thoughts and it's totally subtextual. Also, there was a wonderful opportunity for cross-gender identification, which I always love to do and do whenever I can.

A crossing of lines then between two brothers, joined at the hip, hipsters forever. "I tried to be cool, sitting down in a booth with my Vernor's ginger ale. My brother unzipped his gig bag, raised his trumpet, and sat in with the best of the be-bop bands." I choke up reading this, and I promise to be true to my own brother. Behind these noble words of solidarity, we see the Moor and the woman in a café, sidelined figures of tragic perception.

Just as institutions can be unintentionally good, so rescue can be ineptly bad. In *"People all over are starving,"* 1998, the lip service paid to the starving rings false, the measures taken in its name absurd. You don't save the starving by making Ken eat all his peas.

And something creepy attaches to rescue. In *Got a call from Nick*, 1999, we're reminded that the artist is an undertaker, that museums are mausoleums, and that thanks to them we keep only some of the dead in our midst.

The strange funerary quality of writing does have a peculiarly non-Enlightenment mood, a mood that doubts the efficacy of reason and the availability of justice. It is an insight that was inaugural for deconstruction, the literary and philosophical method that scandalized Lynne Cheney, Allan Bloom, and a legion of cultural conservatives. Deconstruction is about the inherent deceptiveness of language, its failure to perform anything it promises. The words on the gravestone say, "Pause, traveller, and hear my tale."[3] The sad delusion fostered here is that someone lives inside the tomb. And it's not only tombic inscriptions that wish you to believe this fallacy. Language everywhere stands in for something that can never actually present itself. Loss and privation infect writing of every sort. From this angle, Aptekar's glass facades are transparent gravestones. His sandblasted inscriptions subvert these double voices from the

grave, for his glass, unlike a gravestone, reveals the contents of the tomb. Far from impersonating a speaker now sadly absent and enunciating a painting now tragically mute, these works attempt to dispel mournful pretense and outright deception. They challenge the deconstructive view of writing. And they undermine all three pretenses of framing, for Aptekar's glass neither contains, nor stands outside, nor dispassionately observes.

But the deconstructive power of writing and the judgmental aloofness of the frame are not to be so easily disposed of. Despite Aptekar's vital efforts, the exhibition offers some poignant examples of writing-as-privation. Art proves more often than not to mark loss and the flight of authenticity.

> Time comes up for me fairly often. I make specific reference to the present. You know, "I'm walking down Broadway, and I see blah blah blah bluh." So if I do that and I put a text that's extremely of the moment, for example, next to an image that's from a long time ago, then I suggest that something specific happened that prompted a painter to make that painting. And so that's one way in which time figures. Another way is retrieval of memory and another aspect has to do with trying to capture the essence of what happened long ago through a contemporary understanding of the past. For example, in one of the paintings that's going to be in the exhibition based on Rembrandt's *Sampling Officials of the Drapers' Guild* [1662], I have a text that says something like "what would you say to me if you didn't have to judge me, and what would I say to you if I didn't need your money?" That's a dilemma that artists have faced forever; ever since the first artist was commissioned to do any kind of work, an artist's work was being bought by a collector who had some say in how the artist was going to make the work.

And yet the anecdotes, the anecdotal method, suggest a larger point, a point of method.

> I was trying to tease out a love-hate relationship that an artist has with somebody who is supporting their work;

you know, that goes both ways. It's not just, what would you say if you didn't have to judge me? In other words, couldn't you just respond to my work without judging it? Could you just talk about it? What did it mean to you? Instead of everything that you say to me about what I've done having to do with your position of superiority as the person who decides whether I live or ... whether I can afford to eat or not. And what would I say to you if I didn't need your money? Wouldn't I just be able to talk to you as a normal human being without some ulterior motive?

WRITING RESTORED, MUTENESS AT AN END

The fallacy here is that one may attain to some pure condition that has no ulterior motive. But, of course, when Aptekar begins to scoop in focus groups and interviewees, he has his motives which involve balancing optimism against his own shrewd, better knowledge. At the Victoria & Albert Museum in London, England, the artist set up groups to respond to paintings in the collection. He asked them, for example, which painting he should get rid of, not use at all. Then he used their responses as his sandblasted text. Look closely. The views of museum guards and disabled gardeners and inner-city school children, views shyly offered at his urgings, adorn Aptekar's most recent paintings. He is profoundly inviting, and he makes interlopers surmount their fears.

Yet Aptekar's radical realism is such that his Enlightenment optimism always comes face to face with his deconstructive anarchism. A member of the disabled gardeners' group was especially moved by a painting that included a dead barn fowl.

A chicken with its mouth open on the ground ... and this guy was so disabled, he could barely talk, he had difficulty walking, and he just identified with that chicken. "No. He's not dead, he's struggling, and he's alive and he's going to make it." It was so moving, incredible.

There was another guy from the disabled gardener group. He was from one of the islands, and he could

barely talk. He wanted to answer the question about which painting he didn't like. I told them I had too many paintings to work on at one point; tell me which painting you can't stand and why and convince me to get rid of it. And he picked this beautiful seascape, a storm-tossed sea with the boat in danger, you know, in peril. The mast has been broken off and is floating in the water, and a couple of people are rushing around on deck trying to stay on the boat as it is upended. And he said, "I don't want that painting, get rid of that painting." It took him about ten minutes to say five sentences. I thought I would go crazy, this guy was talking … at … this … speed. Squeeeezing out each word. But, you know, he was trying to communicate, I had to listen. It was really one of the most painful things I've ever experienced.

He basically said he didn't want that painting, that I should get rid of that painting because he could hear the sound of the sea; the people are going to drown, the boat is having difficulty—he expressed himself so precisely. The last line is something like, "I don't want to hear the noise." He had translated this visual experience into an aural experience, and in that transformation was this miracle of visceral response. He saw this painting, it meshed with all the fears that must have run rampant in this guy's life because of his disabilities. And I arrive at the opening of the exhibition, and I get to the last gallery where they had put the list of acknowledgments I had drawn up. I wanted to thank certain people, including all of the people in the groups. And I get to the bottom of the list of names of people who are in all the groups and it says, "And John Shoy who sadly died suddenly last month." It didn't say why, but it was of an epileptic seizure.

Aptekar has compelled the museum to incorporate the disabled gardener. How fully incorporated is another question. The museum had neglected to tell him of John Shoy's death.

The museum's forgetfulness suggests why humane and generous motives demand to be subjected to a corrosive critical intelligence. Dialectic is far too hopeful and continuist a word to define Aptekar's edgy, angular, and divided world. Harold Rosenberg once observed that "a contemporary painting or sculpture is but a kind of centaur, half artistic materials, and half words."[4] That is obviously the case in Aptekar's synaesthetic method.

> A serviceable painted surface offers a certain pleasure. There's color, there's movement, there's the embodied hand—all those features that offer viewers of painting, pleasure. Then again, there's the glass over it that reflects things, complicates your view of the painting, prevents your eye from really caressing the surface of the painting uninterrupted; and then there's the text, additionally, to sort of stand in the way of your pure enjoyment of the painted surface. And then there's the dangerous aspect of the glass.

Centaur-like, Aptekar halves criticism into the professional and the populist, judgment into the piggish and the productive, the work into sensuous paint and dangerous glass. He despises institutions and they dominate his project. Even the relations of rescue go both ways. Aptekar enables the disabled gardeners and the Mieke Bals and Norman Brysons. They enable him and—as in the gardeners' case—are incarnate in his work. The mélange of opposites forms no cheery dialectic. We might, optimistically, think of it as affirmative deconstruction, an engaging discourse on the failure of its own premises.

CONCLUSION

The discovery of strength within olio and mastery over the Old Masters recapitulates the painter/autobiographer's own formation. Text and image tend to interrupt each other, and the tension between them argues a competitive urge to have the last word. Such contests create some breathing room, such confusions open lines of flight. But escape is by no means assured. The hapless elder brother, wishing to play the jazz trumpet, has no half-nude Painting to annul parental demands and point the way out. He succumbs to their words and heads to medical school, only to land five days later in the mental hospital.

Aptekar acknowledges the oppressive power of family, temple, public opinion, Art World. But he also affirms a logic of unintended effects that impels his mother to make him an artist and his synagogue to make him a man of fashion. Bal makes the seductive claim that Aptekar's reframings link the other to the self "in an act of solidarity that bestows some of the positive feedback—'they love me'—on the other."[5] And a utopian strand in these works would have us think that the force of authority can be realigned to good ends.

Aptekar is a critical engineer of semiotic reframing. Consistent with his trenchant suspicions about self-generated power, he accepts none of the credit.

> I didn't set out to produce a body of work because I thought I would be reproducing my Jewish heritage. Eventually I realized I was doing it, though. It's a product of my Jewish education and culture. It's a product of a couple thousand years of Jewish skepticism—a Jewish response to the world that says why and mistrusts for any number of reasons, and reflects on why things are, and never accepts any explanation as the last word.

There's never a last word.

NOTES

Notes

1. Timothy Mitchell, *Colonizing Egypt* (Cambridge: Cambridge University Press, 1988; reprint, Berkeley, CA: University of California Press, 1991), p. 46.

2. Giambattista Vico, *The New Science*, 3d ed., trans. Thomas Goddard Bergin and Max Harold Fisch (Ithaca, NY: Cornell University Press, 1970), p. 382.

3. Paul de Man, "Autobiography as De-Facement" in *The Rhetoric of Romanticism* (New York: Columbia University Press, 1984), pp. 77–78.

4. Harold Rosenberg, "Arte y palabras," in *La idea como arte: Documentos sobre el arte conceptual*, ed. Gregory Battack (Barcelona: Gustavo Gili, 1977), pp. 117–126.

5. Mieke Bal, *Acts of Memory: Cultural Recall in the Present*, ed. Mieke Bal, Jonathan Crewe, and Leo Spitzer (Hanover, NH: University Press of New England, 1999), p. 185.

Plates

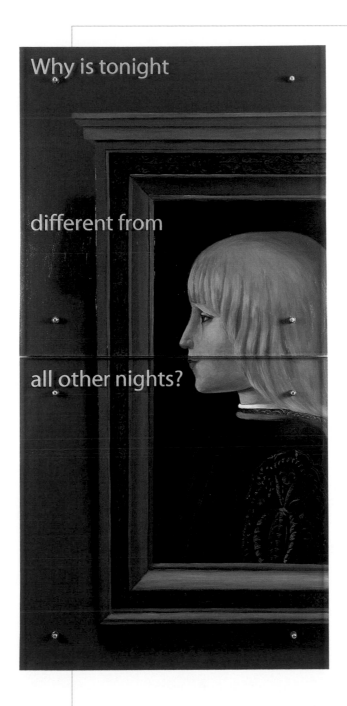

*Four Questions, #1: Why is tonight different … *, 1999
oil paint on wood, sandblasted glass, bolts
60 x 30 inches
Collection of Jon and Carolyn Younger
Short Hills, NJ

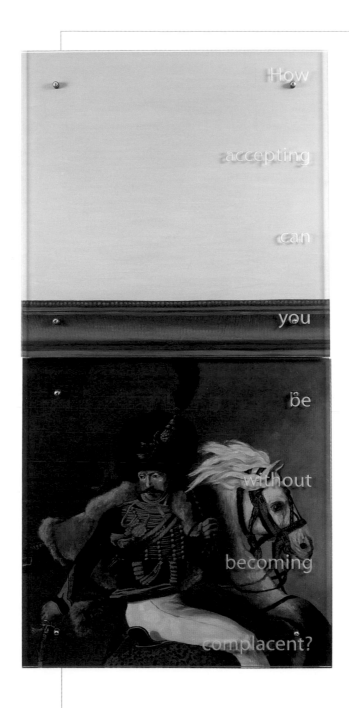

Four Questions, #2: How accepting can you be ... , 1999
oil paint on wood, sandblasted glass, bolts
60 x 30 inches
Collection of Alice and Walker Stites
Louisville, KY

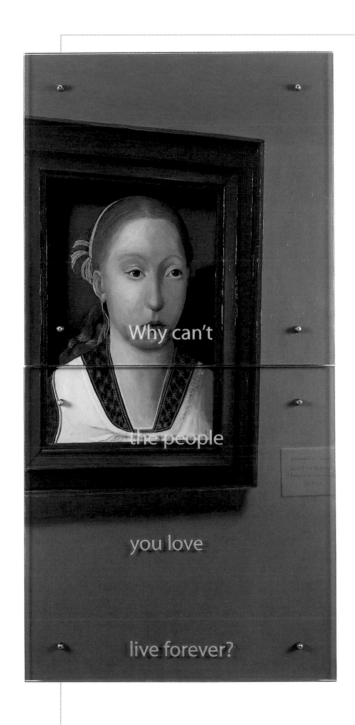

Four Questions, #3: Why can't the people ... , 1999
oil paint on wood, sandblasted glass, bolts
60 x 30 inches
Collection of Steven Robman
Los Angeles, CA

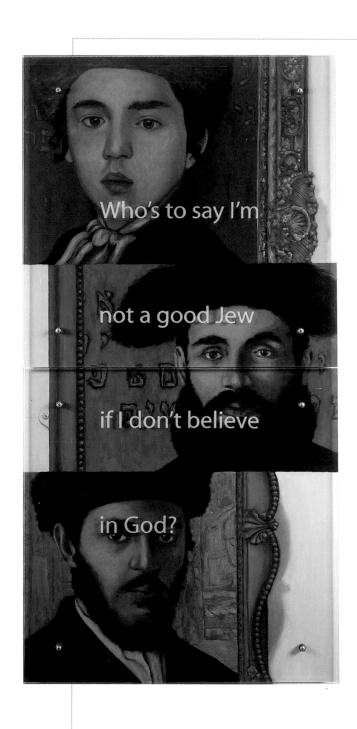

Four Questions, #4: Who's to say … , 1999
oil paint on wood, sandblasted glass, bolts
60 x 30 inches
Collection of Aaron and Marion Borenstein
Coral Gables, FL

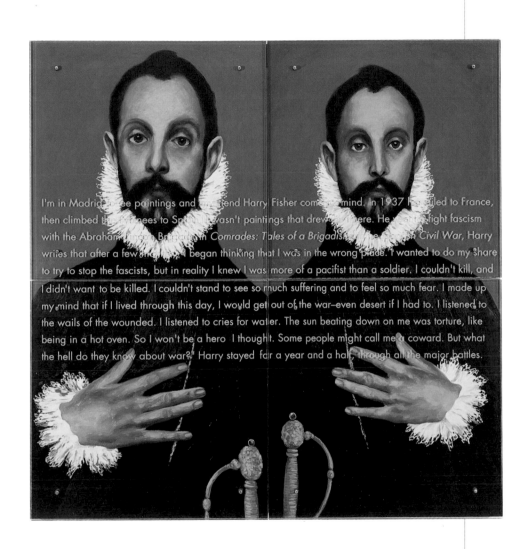

I'm in Madrid [...] paintings and [...] friend Harry Fisher comes [...] mind. In 1937 he [...] to France, then climbed the [...] to Sp[...] wasn't paintings that drew [...] here. He [...] fight fascism with the Abraham [...] Brigade [...] *Comrades: Tales of a Brigadis[...] the S[...] Civil War*, Harry writes that after a few [...] I began thinking that I was in the wrong place. "I wanted to do my share to try to stop the fascists, but in reality I knew I was more of a pacifist than a soldier. I couldn't kill, and I didn't want to be killed. I couldn't stand to see so much suffering and to feel so much fear. I made up my mind that if I lived through this day, I would get out of the war—even desert if I had to. I listened to the wails of the wounded. I listened to cries for water. The sun beating down on me was torture, like being in a hot oven. So I won't be a hero I thought. Some people might call me a coward. But what the hell do they know about war?" Harry stayed for a year and a half, through all the major battles.

I'm in Madrid, 1999
oil paint on wood, sandblasted glass, bolts
60 x 60 inches
Collection of the Kemper Museum of Contemporary Art
Kansas City, MO
Bebe and Crosby Kemper Collection
Gift of the William T. Kemper Charitable Trust
1999.10a–d

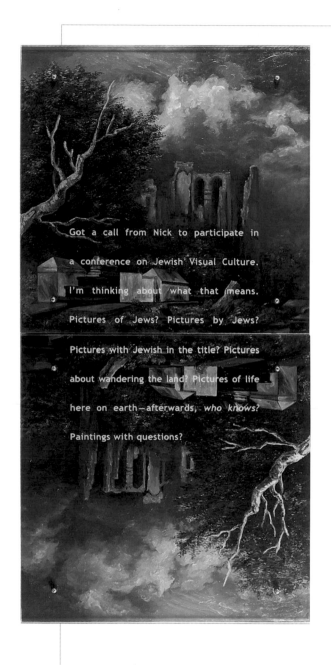

The text within the artwork reads:

Got a call from Nick to participate in a conference on Jewish Visual Culture. I'm thinking about what that means. Pictures of Jews? Pictures by Jews? Pictures with Jewish in the title? Pictures about wandering the land? Pictures of life here on earth—afterwards, *who knows?* Paintings with questions?

Got a call from Nick, 1999
oil paint on wood, sandblasted glass, bolts
60 x 30 inches
Courtesy of Bernice Steinbaum Gallery
Miami, FL

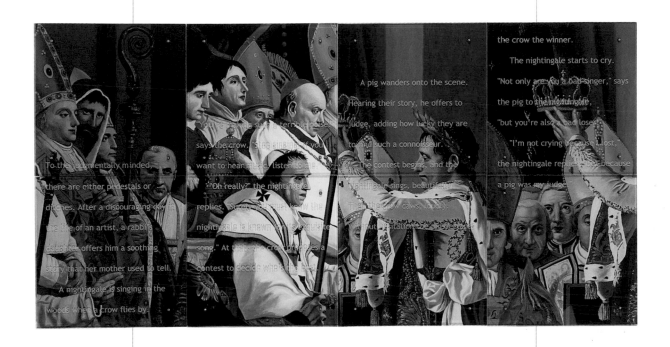

The following text appears within the artwork panels:

To the judgmentally minded, there are either pedestals or ditches. After a discouraging day in the life of an artist, a rabbi's daughter offers him a soothing story that her mother used to tell. A nightingale is singing in the woods when a crow flies by.

"You're making such a terrible noise," says the crow. "Stop singing if you want to hear music, listen to me." "Oh really?" the nightingale replies. "Surely you must know the nightingale is known for its exquisite song." At this, the crow proposes a contest to decide who is the best.

A pig wanders onto the scene. Hearing their story, he offers to judge, adding how lucky they are to find such a connoisseur. The contest begins, and the nightingale sings, beautifully. Then the crow caws, loudly.

the crow the winner.

The nightingale starts to cry. "Not only are you a bad singer," says the pig to the nightingale, "but you're also a bad loser." "I'm not crying because I lost, the nightingale replies, but because a pig was my judge."

To the judgmentally minded, 1999
oil paint on wood, sandblasted glass, bolts
60 x 120 inches
Collection of Harold and Bernice Steinbaum
Miami, FL

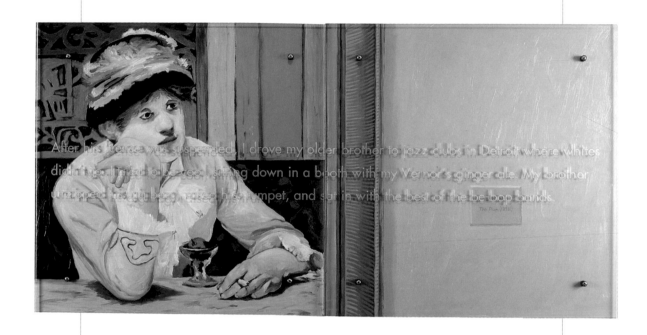

I drove my brother ... , 1999
oil paint on wood, sandblasted glass, bolts
30 x 60 inches
Collection of Dr. Jeff Gelblum
Miami, FL

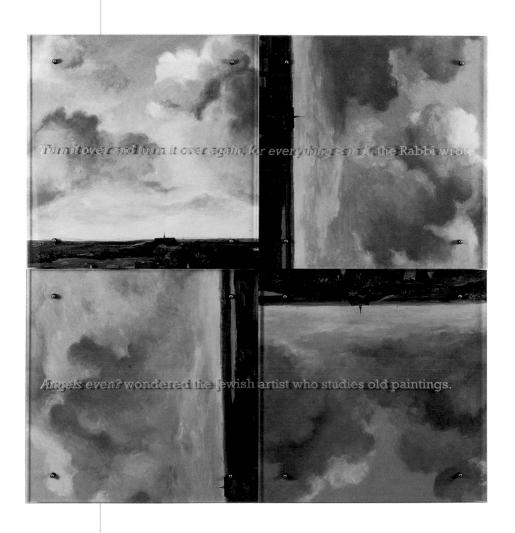

Turn it over, 2000
oil paint on wood, sandblasted glass, bolts
60 x 60 inches
Collection of Saied Azali
Washington, DC

"Angels? Who's ever seen one!"

−Gustave Courbet (1819−1877), French realist painter

"Angels?", 2000
sandblasted glass, bolts
30 x 30 inches
Courtesy of Bernice Steinbaum Gallery
Miami, FL

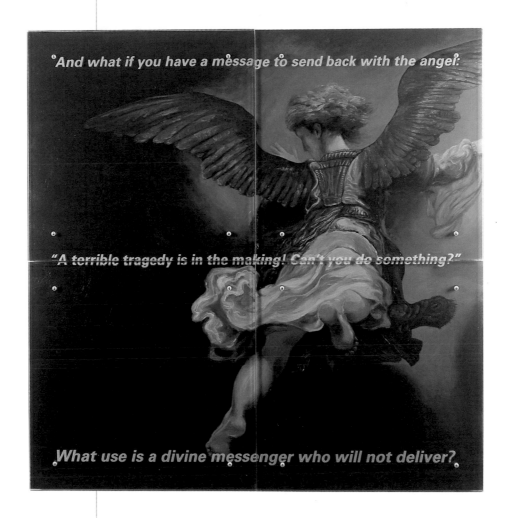

And what if you have a message, 2000
oil paint on wood, sandblasted glass, bolts
60 x 60 inches
Collection of Dr. Jaime and Miriam Wancier
Boca Raton, FL

Ken Aptekar: Painting Between the Lines, 1990–2000
Works in the Exhibition

Dimensions in inches; height precedes width

Safe, 1990
silverpoint on paper, glass, bolts
20 x 20
Collection of Carol Zemel, Toronto, Ontario, Canada

Oversensitive, 1990
oil paint on wood, sandblasted glass, bolts
30 x 30
Collection of David Lipton, Toronto, Ontario, Canada

Raphael with another man, 1991
oil paint on wood, sandblasted glass, bolts
30 x 120
Collection of Mary and John Felstiner, Stanford, CA

Answers/Questions, 1992
oil paint on wood, sandblasted glass, bolts
30 x 60
Collection of Dr. Gail Postal, New York, NY

CIRCLE OF REMBRANDT, 1992
oil paint on wood, sandblasted glass, bolts
30 x 120
Collection of A. Ostojić, Forest Hills, NY

PINK FRICK, 1993
oil paint on wood, sandblasted glass, bolts
60 x 60
Private collection

Was für ein Name ist denn eigentlich Aptekar?, 1994
oil paint on wood, sandblasted glass, bolt
30 x 30
Collection of Dr. Jeff Gelblum, Miami, FL

What would you say to me?, 1994
oil paint on wood, sandblasted glass, bolts
30 x 60
Collection of Saied Azali, Washington, DC

I watch him in the mirror, 1995
oil paint on wood, sandblasted glass, bolts
60 x 30
Collection of J. Cassese and S. Merenstein, New York, NY

We went to the tailor together, 1995
oil paint on wood, sandblasted glass, bolts
90 x 60
Collection of Howard E. Rachofsky, Dallas, TX

"Goldfinch. Used to be Goldfarb.", 1995
oil paint on wood, sandblasted glass, bolts
30 x 30
Courtesy of Will Foster and Jack Shainman Gallery, New York, NY

I hate the name Kenneth, 1996
oil paint on wood, sandblasted glass, bolts
60 x 120
Collection of The Jewish Museum, New York, NY
Museum purchase with funds provided by Barbara S. Horowitz, Howard E.
Rachofsky, Ruth M. and Stephen Durschlag, Marcia May, J. W. Heller
Foundation, Michael L. Rosenberg, the Fine Arts Acquisitions Committee,
Helga and Samuel Feldman, Caroline B. Michahelles and Robert G. Pollock,
1997.26.1–8

I'm six years old and hiding behind my hands, 1996
oil paint on wood, sandblasted glass, bolts
120 x 120
Courtesy of Bernice Steinbaum Gallery, Miami, FL

Her Father Dragged Her From Shtetl to Shtetl, 1996
oil paint on wood, sandblasted glass, bolts
60 x 60
Collection of John Burger, M.D., Edison, NJ

The lights dim in Henry Ford Auditorium, 1997
oil paint on wood, sandblasted glass, bolts
72 x 120
In the Collection of the Corcoran Gallery of Art, Washington, DC
Museum purchase, 1998.18.a–o

Maybe he's coming to the new land, 1997
oil paint on wood, sandblasted glass, bolts
60 x 30
Collection of Louise and Ernest De Salvo, Teaneck, NJ

I'd just look around, 1997
oil paint on wood, sandblasted glass, bolts
30 x 30
Collection of Eunice Lipton, New York, NY

Years Ago I'd See Red, 1998
oil paint on wood, sandblasted glass, bolts
60 x 30
Collection of Esther S. Weissman, Shaker Heights, OH

"People all over are starving," 1998
oil paint on wood, sandblasted glass, bolts
24 x 48
Collection of Robert and Maxine Peckar, Alpine, NJ

We only made bacon on breakfast cookouts, 1998
oil paint on wood, sandblasted glass, bolts
24 x 48
Collection of Dr. and Mrs. G. Bronson, Courtesy Bernice Steinbaum Gallery
Miami, FL

Four Questions, #1: Why is tonight different ... , 1999
oil paint on wood, sandblasted glass, bolts
60 x 30
Collection of Jon and Carolyn Younger, Short Hills, NJ

Four Questions, #2: How accepting can you be ... , 1999
oil paint on wood, sandblasted glass, bolts
60 x 30
Collection of Alice and Walker Stites, Louisville, KY

Four Questions, #3: Why can't the people ... , 1999
oil paint on wood, sandblasted glass, bolts
60 x 30
Collection of Steven Robman, Los Angeles, CA

Four Questions, #4: Who's to say ... , 1999
oil paint on wood, sandblasted glass, bolts
60 x 30
Collection of Aaron and Marion Borenstein, Coral Gables, FL

I'm in Madrid, 1999
oil paint on wood, sandblasted glass, bolts
60 x 60
Collection of the Kemper Museum of Contemporary Art, Kansas City, MO
Bebe and Crosby Kemper Collection
Gift of the William T. Kemper Charitable Trust
1999.10a–d

Got a call from Nick, 1999
oil paint on wood, sandblasted glass, bolts
60 x 30
Courtesy of Bernice Steinbaum Gallery, Miami, FL

To the judgmentally minded, 1999
oil paint on wood, sandblasted glass, bolts
60 x 120
Collection of Harold and Bernice Steinbaum, Miami, FL

I drove my brother ... , 1999
oil paint on wood, sandblasted glass, bolts
30 x 60
Collection of Dr. Jeff Gelblum, Miami, FL

Turn it over, 2000
oil paint on wood, sandblasted glass, bolts
60 x 60
Collection of Saied Azali, Washington, DC

"Angels?", 2000
sandblasted glass, bolts
30 x 30
Courtesy of Bernice Steinbaum Gallery, Miami, FL

And what if you have a message, 2000
oil paint on wood, sandblasted glass, bolts
60 x 60
Collection of Dr. Jaime and Miriam Wancier, Boca Raton, FL

Biography

1950 Detroit, Michigan

1975 M.F.A., Pratt Institute, Brooklyn, NY
1973 B.F.A., University of Michigan, Ann Arbor, MI

1998 Mid Atlantic Arts Foundation, Artist-as-Catalyst Award
 (in conjunction with Pyramid Atlantic and George Mason
 University)

1995 National Endowment for the Arts Fellowship in Painting

1994 Djerassi Resident Artists Program Residency, Woodside, CA

1992 Rockefeller Foundation Artist Residency, Bellagio, Italy

1992 Ucross Foundation Artist Residency, Clearmont, WY

1991 Djerassi Resident Artists Program Residency, Woodside, CA

1989 Pollock-Krasner Foundation Award

1987 National Endowment for the Arts Fellowship in Painting

2001 *Ken Aptekar: Painting Between the Lines, 1990–2000*
Kemper Museum of Contemporary Art, Kansas City, MO
The College of Wooster Art Museum, Wooster, OH
Muscarelle Museum of Art, College of William and Mary, Williamsburg, VA

Companion Portraits: A Collaborative Project by Rembrandt van Rijn &
Ken Aptekar, Pamela Auchincloss Project Space, New York, NY

Q&A, V&A, Commissioned exhibition for the Victoria & Albert Museum,
London, England in conjunction with the Serpentine Gallery, London, England

Angels?, Bernice Steinbaum Gallery, Miami, FL

1999 *So What Kind of Name is That: Paintings with Text by Ken Aptekar*
Elaine L. Jacob Gallery, Wayne State University, Detroit, MI

Four Questions & Other Pictures, Steinbaum Krauss Gallery, New York, NY

1997–98 *Ken Aptekar: Talking to Pictures*, Corcoran Gallery of Art, Washington, DC

1996 *Ken Aptekar: New Paintings*, Jack Shainman Gallery, New York, NY

1995 *Rembrandt Redux: The Paintings of Ken Aptekar*
Palmer Museum of Art, Pennsylvania State University, University Park, PA
Cummer Museum of Art and Gardens, Jacksonville, FL

1994 *Rembrandt's Problem*, Jack Shainman Gallery, New York, NY

1990 Margulies Taplin Gallery, Coral Gables, FL

1989 Bess Cutler Gallery, New York, NY

1984 Sid Deutsch Gallery, New York, NY

1983 *On View*, New Museum of Contemporary Art, New York, NY

1980 Art Galaxy, New York, NY

1979 Art Latitude, New York, NY

2000 *Intersecting Identities: Jewishness at the Crossroads*
Staller Center for the Arts, State University of New York at Stony Brook,
Stony Brook, NY

Portraits and Cultural Identity
Skirball Cultural Center and Museum, Los Angeles, CA

The Perpetual Well: Contemporary Art from the Collection of The Jewish Museum
Samuel P. Harn Museum of Art, University of Florida, Gainesville, FL
Sheldon Memorial Art Gallery, University of Nebraska, Lincoln, NE
Parrish Art Museum, Southampton, NY
Huntington Museum of Art, Huntington, WV

Les Cent Sourires de Monna Lisa
Tokyo Metropolitan Art Museum, Japan
Shizuoka Prefectural Museum, Shizuoka, Japan
Hiroshima Prefectural Art Museum, Japan

1998–00 *Beyond the Mountains: The Contemporary American Landscape*
Asheville Art Museum, NC
Woldenberg Art Center of Newcomb College, Tulane University, New Orleans, LA
Muskegon Museum of Art, MI
Polk Museum of Art, Lakeland, FL
Boise Art Museum, ID
Fort Wayne Museum of Art, IN
Lyman Allyn Museum of Art, Connecticut College, New London, CT

1998 *Borrowing*
Islip Art Museum, East Islip, NY

1996–97 *Too Jewish? Challenging Traditional Identities*
Jewish Museum, New York, NY
Jewish Museum, San Francisco, CA
Hammer Museum of Art and Cultural Center, Los Angeles, CA
Contemporary Museum of Art, Baltimore, MD
National Museum of American Jewish History, Philadelphia, PA

1996 *Masculine Measures*
John Michael Kohler Arts Center, Sheboygan, WI

Narcissism: Artists Represent Themselves
California Center for the Arts, Escondido, CA

1995 *Arts Sans Frontieres*
Ecole du Versant, Larouche, Quebec, Canada

Going for Baroque
Walters Art Gallery, Baltimore, MD

Human/Nature
New Museum of Contemporary Art, New York, NY

Recent Acquisitions
Corcoran Gallery of Art, Washington, DC

1994 *New Old Masters*
Yerba Buena Center for the Arts, San Francisco, CA

Bad Girls West
Frederick S. Wight Art Gallery, University of California, Los Angeles, CA

1993 *43rd Biennial Exhibition of Contemporary American Painting*
Corcoran Gallery of Art, Washington, DC

Benefit Exhibition
New Museum of Contemporary Art, New York, NY

The Purloined Image
Flint Institute of Arts, MI

1992 *Decoding Gender*
School 33 Art Center, Baltimore, MD

1991 *New Generations: New York*
Carnegie Mellon Art Gallery, Pittsburgh, PA

Drawing Time
Snug Harbor Cultural Center, Newhouse Center for Contemporary
Art, Staten Island, NY

1990 *Post-Boys & Girls: Nine Painters*
Artists Space, New York, NY

Critical Revisions
Bess Cutler Gallery, New York, NY

June 4, 1989, China
P.S.1 Contemporary Art Center, Long Island City, NY

1989 *Gender Fictions*
Binghamton University Art Museum, Binghamton, NY

1989 *Serious Fun, Truthful Lies*
Randolph Street Gallery, Chicago, IL

1987 *The Other Man: Alternative Representations of Masculinity*
New Museum of Contemporary Art, New York, NY

1986 *Group Painting Exhibition*
Art in General, New York, NY

1982 *What I Do For Art*
Just Above Midtown/Downtown Gallery, New York, NY

1981 *Five Photographers*
Midtown Y Photography Gallery, New York, NY

1978 *Two-Person Exhibition of Bookworks*
Franklin Furnace Archive, Inc., New York, NY

1977 *2nd International Festival of Avant-Garde Cinema*
Caracas, Venezuela, Film: "Time Return"

SELECTED COLLECTIONS

Lucille Aptekar and Gerald Leader, Brookline, MA
Bank of Boston, Boston, MA
BellAtlantic Corporation, New York, NY
Castellani Art Museum of Niagara University, Niagara Falls, NY
Contemporary Art Society, London, England
Corcoran Gallery of Art, Washington, DC
Denver Art Museum, CO
Carl Djerassi and Diane Wood Middlebrook, San Francisco, CA and London, England
Edward R. Downe, Jr. Collection, New York, NY
Steve and Ruth Durschlag, Chicago, IL
Nancy and Peter Gennet, Sonoma, CA
Harvard Business School, Cambridge, MA
Barry and Arlene Hochfield, Philadelphia, PA
Jewish Museum, New York, NY
Kemper Museum of Contemporary Art, Kansas City, MO
National Museum of American Art, Washington, DC
Progressive Corporation, Cleveland, OH
Howard E. Rachofsky Foundation, Dallas, TX
Reader's Digest Art Collection, Pleasantville, NY
World Bank, Washington, DC

BIBLIOGRAPHY

Aptekar, Ken. "Dear Rembrandt." *Art Journal*, College Art Association
(Fall 1995): pp. 12–13.

———. "Why I Went for Baroque." *Monthly Bulletin* (April 1996): pp. 4–5.

———. "On Painting an American Jewish Picture." *Jewish Currents*
(October 1996): pp. 5–7.

———. "Ken Aptekar: Talking to Pictures." Interview by Robert Siegel,
All Things Considered. National Public Radio, 24 October 1997.

Atkins, Robert. "New This Week: Ken Aptekar." *Seven Days*, 5 December 1989.

———. "Four Questions & Other Pictures." Exhibition catalogue essay, 1999.
Four Questions & Other Pictures. Steinbaum Krauss Gallery,
New York, NY.

Baker, Kenneth. "Contemporary Painting Celebrated in D. C." *San Francisco
Chronicle*, 7 November 1993.

Bal, Mieke. "Paintings 'R' Us." Exhibition catalogue essay, 2001. *Companion
Portraits: A Collaborative Project by Rembrandt van Rijn & Ken Aptekar*.
Pamela Auchincloss Project Space, New York, NY.

———. "Auf die Haut/Unter die Haut: Barockes steigt an die Oberfläche."
Barock: Nene Sichtweweisen Einer Epoche. Ed. Peter J. Burgard. Vienna:
Böhlau Verlag (2001): pp. 17–51.

———. "Sticky Images: The Foreshortening of Time in an Art of Duration."
Time and the Image. Ed. Carolyn Bailey Gill. Manchester, England and
New York, NY: Manchester University Press (2000): pp. 79–99.

———. "Memories in the Museum: Preposterous Histories for Today." *Acts of
Memory: Cultural Recall in the Present*. Ed. Mieke Bal, Jonathan Crewe,
and Leo Spitzer. Hanover, NH: University Press of New England (1999):
p. 185.

———. *Quoting Caravaggio: Contemporary Art, Preposterous History*. Chicago, IL:
University of Chicago Press, 1999.

———. *Narratology: Introduction to the Theory of the Narrative*, 2d ed., Toronto: University of Toronto Press, 1997.

———. *Over Kunst, Literatuur en Filosofie: Liber Amicarum.* Ed. H. J. Pott, V. Vasterling, R. Van de Vall, and K. Vintges. Amsterdam: Royal Boom Publishers, 1997.

———. "Larger Than Life: Reading the Corcoran Collection." Exhibition catalogue essay, 1997. *Ken Aptekar: Talking to Pictures.* Corcoran Gallery of Art, Washington, DC.

Boime, Albert. "Aptekar's Family Album." Exhibition catalogue essay, 1997. *Ken Aptekar: Talking to Pictures.* Corcoran Gallery of Art, Washington, DC.

Bruun, Peter. "Talking Pictures." Exhibition catalogue essay, 2001. *Ken Aptekar: Talking to Pictures.* The Park School, Baltimore, MD.

Bryson, Norman. "The Viewer Speaks." *Art in America* (February 1999): pp. 98–101.

Burchard, Hank. "Out of the Fire, Into the Melting Pot." Washington Post, 29 October 1993.

Cavazos, Nicole. "Feminist Rage, Bad Girls West Takes Hollywood by Groin at Wight Art Gallery." *Daily Bruin*, 25 January 1994.

Cembalist, Robin. "Paintings That Get Personal." *Forward*, 25 October 1996.

Corrin, Lisa. "A Speculative Introduction to a Speculative Exhibition." Exhibition catalogue essay, 2001. *Give & Take.* Serpentine Gallery, London, England.

Dixon, Glenn. "Ken Aptekar: Talking to Pictures." *Washington City Paper*, Washington, DC, 24 October 1997.

Drohojowska-Philp, Hunter. "And When They Were Bad ..." *Los Angeles Times,* 16 January 1994.

Edelman, Robert G. "The Figure Returns: 43rd Corcoran Biennial." *Art in America* (March 1994): pp. 39–43.

Frye, Carrie A. A. "Goodbye, Hello, Landscape Painting: Taking in the View from Beyond the Mountains." *Mountain Xpress*, Asheville, NC, 8 April 1998.

Gibson, Eric. "Who Are the New Stars of Painting?" *Washington Times*, Washington, DC, 2 November 1993.

Glueck, Grace. "Critics' Choices." *New York Times*, 20 June 1982.

Grimes, Nancy. "Ken Aptekar at Jack Shainman." *Art in America* (November 1994): pp. 130–131.

Hagen, Aernout. "Ken Aptekar kiest uit Rembrandts hoedencollectie." *Kroniek van Het Rembrandthuis* (Chronicle of the Rembrandt House), no. 1 (1995).

Harrison, Helen. "Surrealism, Traditionalism, and Re-Visionism." *New York Times*, 11 October 1998.

Hawley-Ruppel, Wendy. "Remaking the Past in Our Own Image." Exhibition catalogue essay, 1994. *New Old Masters*. Yerba Buena Center for the Arts, San Francisco, CA.

Heller, Scott. "Other Voices, Other Rooms." *ArtNews* (April 1998): p. 34.

Henry, Gerrit. "Ken Aptekar at Bess Cutler." *Art in America* (June 1990): pp. 179–80.

Hess, Elizabeth. "Yesterday's Children." *Village Voice*, 4 December 1990.

Kimmel, Michael. "Too Jewish? What Do You Mean By That? Izzat a Stereotype? … " *Westsider*, 11 April 1996.

Knaff, Devorah. "Standing Out, Blending In, Knowing Oneself." *San Diego Union-Tribune*, 16 February 1997.

Knight, Christopher. "Bad Girls: Feminism on Wry." *Los Angeles Times*, 8 February 1994.

Lewis, Jo Ann. "A Fresh Layer of Meaning." *Washington Post*, 8 November 1997.

McCracken, David. "Exhibit Has Its Fun and Its Serious Sides." *Chicago Tribune*, 10 March 1989.

McWilliams, Martha. "Go Figure." *Washington City Paper*, Washington, DC, 12 November 1993.

Miller, Donald. "Contemporary Shows Join with Rembrandt Etchings." *Pittsburgh Post Gazette*, 4 February 1995.

Nochlin, Linda. "Uncertain Identities: Portrait of the Artist as a Young Jew." Exhibition catalogue essay, 2001. *Ken Aptekar: Painting Between the Lines, 1990–2000*. Kemper Museum of Contemporary Art, Kansas City, MO.

Raynor, Vivien. "Bedrooms and Drawings." *New York Times*, 17 February 1991.

Risatti, Howard. "43rd Corcoran Biennial." *Artforum* (March 1994): p. 92.

Roth, Charlene. "Bad Girls." *Artweek*, 10 March 1994.

Safavi, Charlotte. "Deconstructing Rembrandt: Ken Aptekar Takes Another View of the Master with Rembrandt Redux." *Folio Weekly*, Jacksonville, FL, 7 April 1997.

Sangster, Gary. "Ken Aptekar." Exhibition catalogue essay, 1994. *43rd Corcoran Biennial of American Painting*. Corcoran Gallery of Art, Washington, DC.

Saslow, James. "Rethinking Masculinity: Ken Aptekar." *Advocate*, 22 May 1990.

Self, Dana. "Ken Aptekar: Writing Voices." Exhibition catalogue essay, 2001. *Ken Aptekar: Painting Between the Lines, 1990–2000*. Kemper Museum of Contemporary Art, Kansas City, MO.

Shearing, Graham. "Remarkable Rembrandt: Three Shows Celebrate the Artist." *Pittsburgh Tribune-Review*, 15 January 1995.

Shortal, Helen. "Bodily Fluids: School 33 Deconstructs the Birds and the Bees." City Paper, Baltimore, MD, 6 March 1992.

Silk, Gerald. "Reframes and Refrains: Artists Rethink Art History." *Art Journal*, College Art Association (Fall 1995): pp. 10–11.

Smith, Kelly Ann. "The National Art Scene: Preserving and Making Available America's Film Heritage." *New York Times*, 5 January 1997.

Sultan, Terrie. Introduction to exhibition catalogue, 1997. *Ken Aptekar: Talking to Pictures*. Corcoran Gallery of Art, Washington, DC.

Veeser, H. Aram. "Judgment, Rescue, and the Realignment of Painting." Exhibition catalogue essay, 2001. *Ken Aptekar: Painting Between the Lines, 1990–2000*. Kemper Museum of Contemporary Art, Kansas City, MO.

Zimmer, William. "Kenneth Aptekar at Sid Deutsch." *Arts Magazine* (May 1984).

———. "Ken Aptekar." *Soho Weekly News*, 22 November 1979.